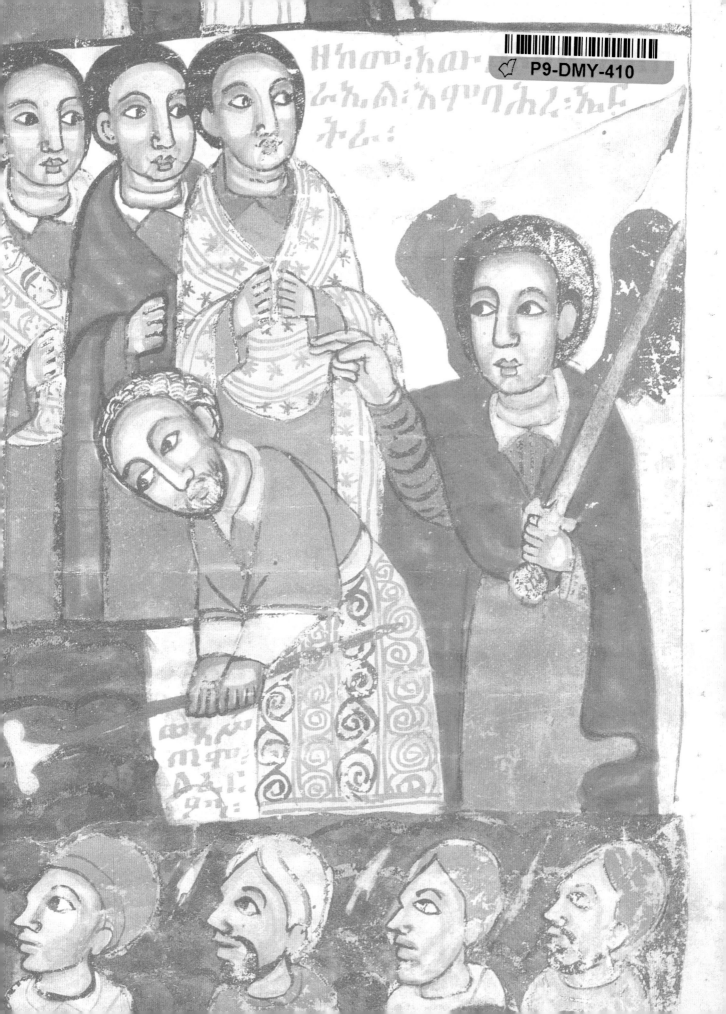

EthiopianArt

The Walters Art Museum

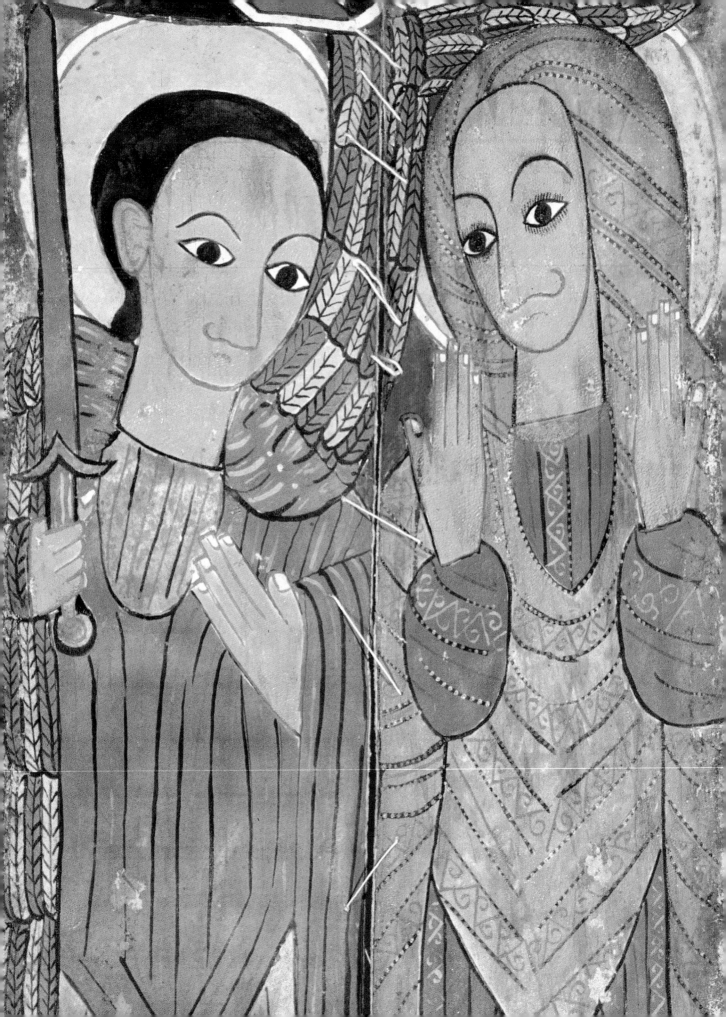

EthiopianArt
The Walters Art Museum

The WALTERS
ART MUSEUM

III
THIRD MILLENNIUM
PUBLISHING

First published in 2001 by Third Millennium Publishing Limited,
a subsidiary of Third Millennium Information Limited
Shawlands Court, Newchapel Road,
Lingfield, Surrey RH7 6BL, UK
www.tmiltd.com

ISBN Paperback 0-911886-52-4
ISBN Hardback 1-903942-02-0

All measurements are in inches and centimeters;
Height precedes width precedes depth.

Edited by Deborah E. Horowitz, The Walters Art Museum
Photography by Susan Tobin, The Walters Art Museum
Selected translation and copy-editing by Honeychurch Associates, Cambridge, UK
Designed by and produced by Pardoe Blacker Limited, a subsidiary of
Third Millennium Information Limited
Printed in Hong Kong

Map by Archeographics (www.archeographics.com)
Photograph Credits:
Georg Gerster, figures 5, 8, 9, 10, 12
Jacques Mercier, figures 6, 7, 11, 14, 16, 19, 20, 24, 26, 27, 31
Karin Maucotel, Paris Musées, 2000, figure 21

Front cover illustration: *Follower of Fre Seyon,* **Diptych with Virgin and Child flanked by
archangels, apostles, and Saint George** (detail), Ethiopia (Tegray), late 15th century (cat. 21)
Back cover illustration: **Hand Cross,** Ethiopia, 18th–19th century (cat. 8)
Frontispiece: **Folding Processional Icon in the Shape of a Fan** (detail), Ethiopia (Gunde
Gunde), late 15th century (cat. 17)
Foreword: **Homiliary and Miracles of the Archangel Michael,** Folio 90 (detail), Ethiopia
(Gondar), late 17th century (cat. 15)

Contents

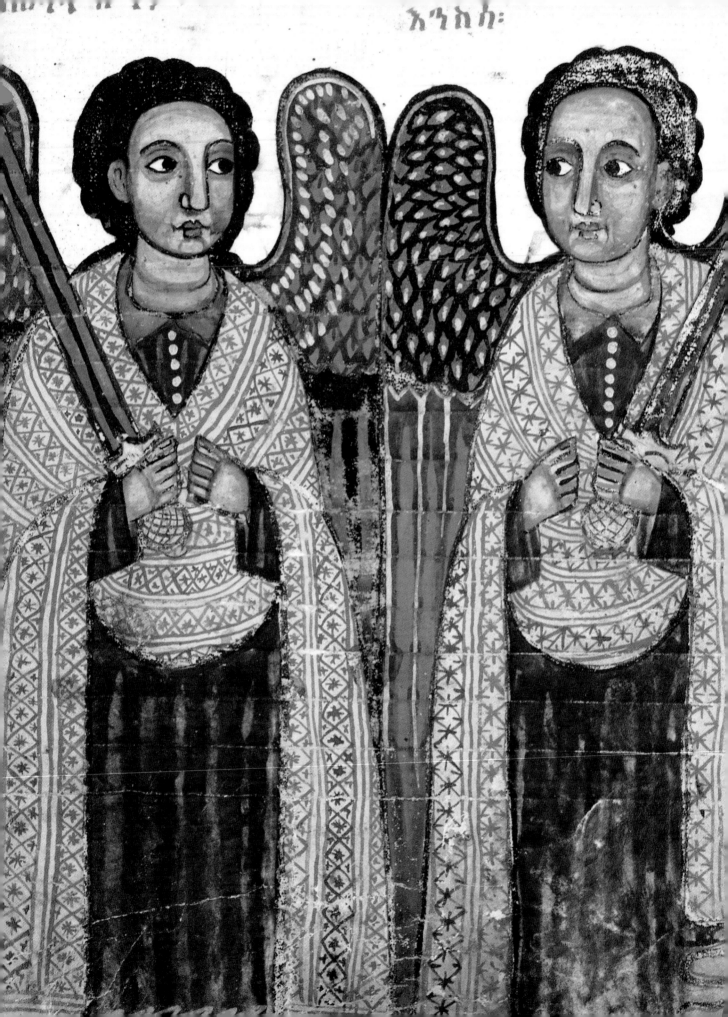

Foreword

The art of Ethiopia is a relatively new addition to the diverse cultures and countries represented by the collections of the Walters Art Museum. Acquired mostly since 1993, the Ethiopian collection has grown rapidly in both depth and breadth, and is now one of the largest and finest outside of Ethiopia itself. It is also one of the new great treasures of this museum, whose original holdings were privately assembled by William T. and Henry Walters between the 1850s and 1920s. Both father and son were avid collectors with far-ranging interests, acquiring works of art from 3500 B.C. through the early twentieth century. When Henry Walters died in 1931, he bequeathed his gallery and over 20,000 objects to the City of Baltimore.

Although Ethiopian art was not among the areas collected by the museum's founders, it nevertheless builds on the strengths of their rich holdings in the art of the eastern Orthodox world. As can be seen in this publication, the art of the Christian kingdom of Ethiopia is characterized by beautiful processional crosses, painted icons, and illuminated manuscripts that were used in the rituals and services of the church. These works of art, like of those of Russia, had been influenced by the crosses and icons made for use in the Byzantine Church and in the homes of the faithful. Now, for the first time, the three cultures of Byzantium, Russia, and Ethiopia are exhibited together in a permanent gallery devoted to the art of the Orthodox world.

These momentous changes have come about at the Walters due to the interest, enthusiasm, and dedication of the many supporters of the Ethiopian collection. The art of this great African nation was first brought to our attention in 1993 by Roderick Grierson, who, through the nonprofit group InterCultura, helped bring the landmark exhibition *African Zion: The Sacred Art of Ethiopia* to the museum. The Walters' collection began to grow in the following years and would not be what it is today without the knowledge and discriminating taste of collectors like Nancy and Robert Nooter, Joseph and Margaret Knopfelmacher, Mrs. Lily Mobille-Pappas, Daniel Friedenberg, Richard Hubbard Howland, and Richard White. The new gallery that houses the Ethiopian collection is made possible by the generosity of Sylvia and Eddie Brown.

The Ethiopian collection is presented here for the first time in a publication that was generously supported by Sam Fogg, whose keen eye and experience in the art world are matched only by his dedication to the Walters. It is also my pleasure to acknowledge the contribution of Amsale Geletu, a member of our African American Steering Committee. With regard to the book's content, I would like to thank all of the writers, as well as Kelly Holbert, Assistant Curator for Medieval Art and Volume Editor, Deborah Horowitz, Editor of Curatorial Publications, and Susan Tobin, Head of Photography, for all of their time, effort, and dedication to this project.

Gary Vikan
Director

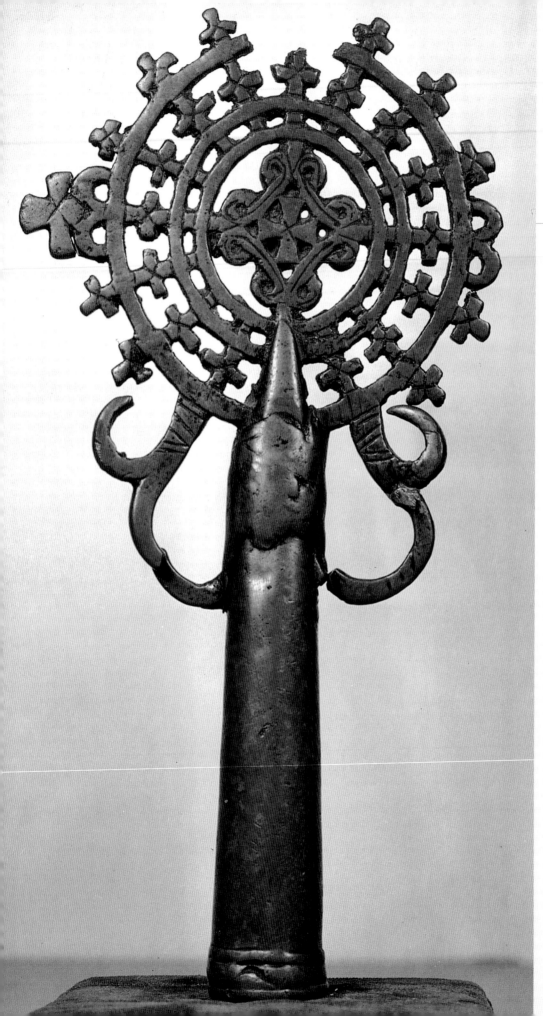

Fig. 1

Processional cross,
Ethiopia, 14th–15th
century, bronze, 8¾ x
4½ in (22.2 x 11.5 cm),
54.1710, Walters Art
Museum, acquired by
Henry Walters, 1925

The Ethiopian Collection of the Walters Art Museum

KELLY M. HOLBERT

Assistant Curator for Medieval Art, The Walters Art Museum

Henry Walters would have been greatly surprised to learn that he was the first to add Ethiopian art to the collection. In 1925, he purchased a bronze processional cross that he thought had been made in Egypt between the fifth and seventh centuries (fig. 1). This cross, later attributed to Ethiopia, remained the sole example of Ethiopian art at the Walters until the 1970s, when the addition of an icon, a prayerbook, and a healing scroll brought the number to a grand total of four.

The situation changed dramatically in the 1990s, when the Walters progressed from having little Ethiopian art to owning the largest and most significant collection outside of Addis Ababa. In the space of only five years (1993–98), through a series of astute purchases and generous donations, the number of works of art of various media had grown from four to 216.

The 1993 exhibition *African Zion: The Sacred Art of Ethiopia*, organized by the arts and educational group InterCultura, could be considered the pivotal event that launched the Walters into this new area of collecting. *African Zion*, the first exhibition of Ethiopian art to travel to the United States, was a landmark presentation of illuminated manuscripts, painted icons, and metalwork crosses that documented the art of Christian Ethiopia from the thirteenth through eighteenth centuries. When *African Zion* went on view at the Walters, the reaction from critics and audience alike was overwhelming. The interest and enthusiasm of viewers for the art of Ethiopia surpassed all expectation and brought into sharp focus the need for the Walters to display more culturally diverse art.

The determination to bring Ethiopian art to the Walters was influenced not only by the positive reception of the exhibition, but also by the conviction that Ethiopian art would perfectly complement the museum's rich holdings of Byzantine, Russian, and western European art. Historically, Ethiopia was a Christian kingdom with strong ties in both trade and religion to the cultures located around the Mediterranean. By the fifteenth century, this African nation had developed a tradition of icon-painting that rivaled the Orthodox empires of Byzantium and Russia, as well as the famed panel paintings of Renaissance Italy. That Ethiopian artists were aware of these other traditions is made apparent in their choice of religious subjects, such as Saint George on horseback or Mary with the Christ Child, which were adapted from Byzantine or Italian models. Nevertheless, a survey of Ethiopian art, from crosses to icons to manuscripts, makes clear that, over time, Ethiopian artists transformed their

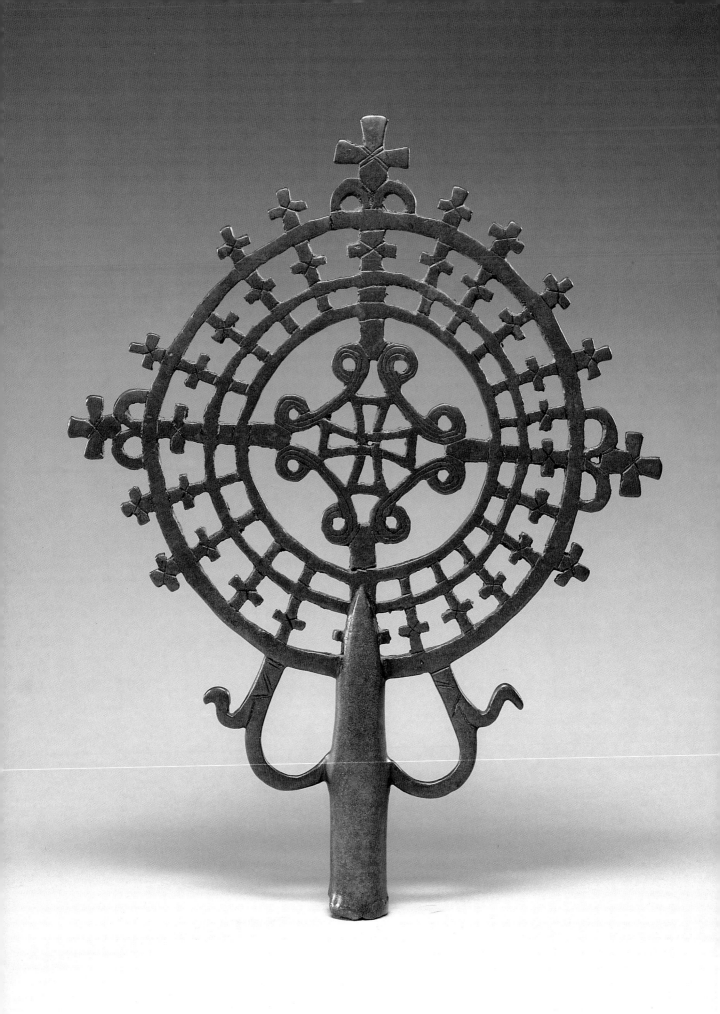

models and infused their works with a unique sense of form and color.

These interconnections were revealed through *African Zion*, and just two years later the Walters had the opportunity to acquire four of the works that had been in that exhibition. These pieces, together with a group of twelve others of comparable high quality (fig. 2), came from two of the most notable private collectors of Ethiopian art in the United States: Joseph and Margaret Knopfelmacher, in New York, and Nancy and Robert Nooter, in Washington, D.C. Over the next few years, the Walters' collection was further enhanced by generous donations of crosses, coins, and single manuscript leaves from both the Knopfelmachers and the Nooters.

Other donors have also come forward, helping to bring our Ethiopian collection up to its current high standard. Many of these collectors have personal ties to Ethiopia, having lived and traveled in that country between 1950 and 1974, the latter date marking the revolution and overthrow of the last Ethiopian emperor, Haile Selassie (reigned 1930–74). The objects they purchased were mostly found in public markets and villages, and many of the coins and small objects are described as having emerged from the soil during periods of heavy rain. A few pieces were also acquired at auction, and from art dealers in Paris, London, and New York.

Ethiopian art continued to be celebrated at the Walters well beyond the landmark exhibition of *African Zion*. In 1997, *Art that Heals: The Image as Medicine in Ethiopia* presented the religious beliefs that underly the use of healing scrolls, manuscripts, and crosses in Ethiopia's past and present. The exhibition introduced visitors to such

Fig. 2

Processional cross, 54.2890,
Walters Art Museum (cat. 3)

Fig. 3

Group of seven coins,
Ethiopia, 3rd–7th century,
gold, silver, and bronze,
average diameter ⅗₆ in (1.5
cm), 59.795.1–90, Walters Art
Museum, gift of Joseph and
Margaret Knopfelmacher,
1998

themes as the use of healing scrolls, the nature of the sick body, and visual trances and healing. An accompanying display presented thirty seven works of art from the Walters' newly acquired collection. In 1998, a gift of ninety coins from the Knopfelmachers added a new dimension to the heretofore almost exclusively religious nature of the collection (fig. 3). In that same year, the Walters purchased one of its finest manuscripts, a Gunda Gunde Gospel book dating to the mid-sixteenth century and illustrated with many beautiful, full-page miniatures (fig. 4).

The history of the Walters' collection of Ethiopian art does not end with the twentieth century, but continues into the next millennium. In 2001, the museum began the year by acquiring a rare diptych icon celebrated for its tender portrayal of the Virgin and Child (cat. 21 and cover illustration). Given Henry Walters' appreciation for Russian and Byzantine icons, he would have been pleasantly surprised to discover that Christian Ethiopia had impressive icons such as this, as well as other works of art that would one day make up one of the most highly acclaimed collections at the Walters Art Museum.

Fig. 4

Our Lady Mary with Her Beloved Son and Archangels, W.850, folio 3, Walters Art Museum (cat. 14)

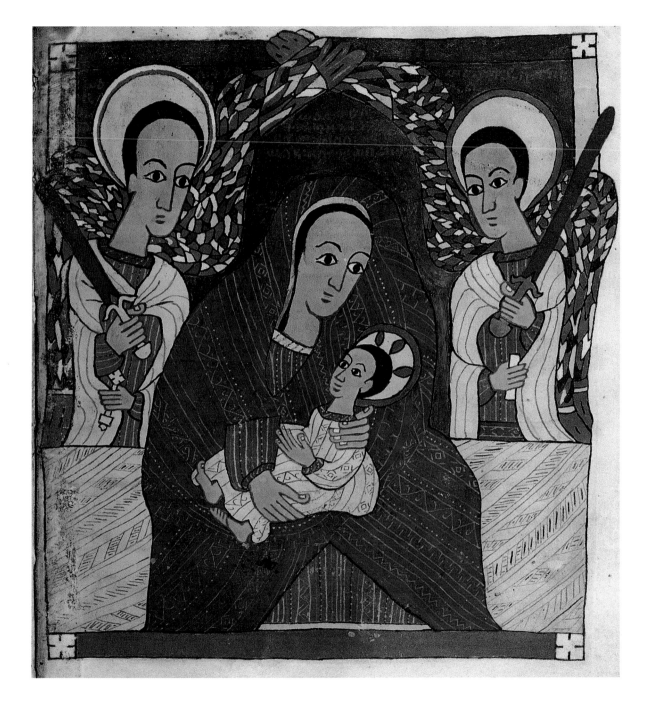

Important dates

ca. 324
Conversion to Christianity of Ezana, King of Aksum

700–1000
Decline of Aksumite kingdom

1137–1270
Zagwe dynasty

1170–1200
Rock-hewn churches are built at Lalibala

1270–1530
Early Solomonic dynasty

1382–1413
Reign of Emperor Dawit, who commissioned the first Ge'ez translation, from Arabic, of the *Miracles of Mary*

1434–68
Reign of Emperor Zär'a Ya'eqob, who in the 1440s introduced the mandatory veneration of Our Lady Mary and her icon

1445–80
Career of the court painter Fre Seyon

1527–43
Adalite *Jihad* against Ethiopia

1555–1632
Jesuit missionaries active in Ethiopia

1632–1769
Later Solomonic dynasty, Gondarine period

1636
Gondar established as the capital

1889–1908
Reign of Menilek II, during the period of the attempted colonization of Ethiopia by England, France, and Italy

1892
Addis Ababa established as the new capital

1930–74
Reign of Haile Selassie, last monarch of Ethiopia

1994
Eritrea secedes from Ethiopia

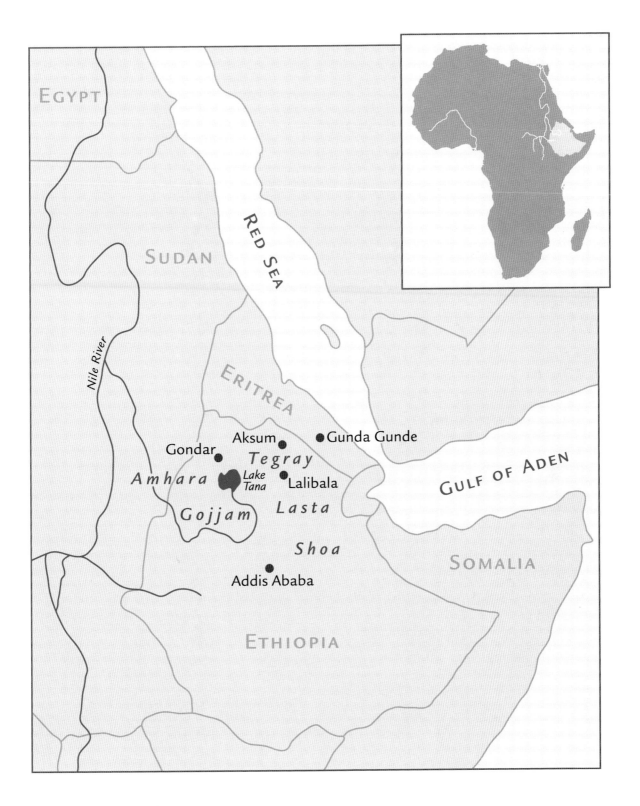

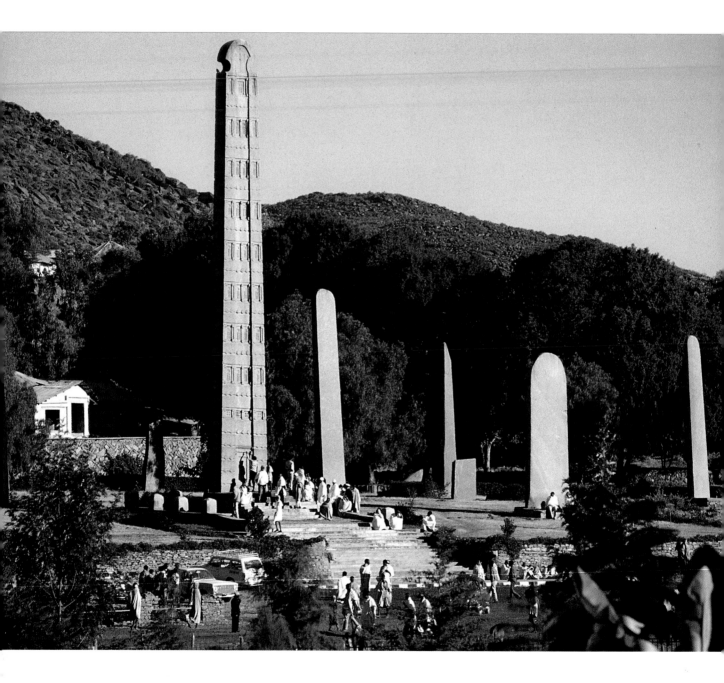

Daily Life and Religious Practices in Ethiopia

GETATCHEW HAILE

Hill Monastic Manuscript Library,
St. John's University, Collegeville, Minnesota

Since the fourth century, the beliefs and rituals of Christianity have had a great impact on Ethiopia's culture and history. This influence began around A.D. 324, when Ezana, the ruler of what was then the Aksumite kingdom, converted to Christianity. Aksum was at that time a well-established state with trading ties to Egypt, Arabia, and the eastern Mediterranean. These connections would be enhanced over the centuries, leading at times to harmonious relations with Christian countries in the West, such as Italy and Portugal, and at other times to war with neighboring Islamic lands.

In the central part of the country, this Christian culture continues to affect daily life, as villagers in the rural highlands observe church rituals and societal traditions in much the same way they did centuries ago. Life in the capital city of Addis Ababa, many of whose inhabitants have roots in the countryside, is also informed by Judeo-Christian beliefs. Yet, as is the case in the urban centers of most non-western countries, life here is increasingly influenced by secular western culture. The importation of clothing, food, and music, as well as conveniences such as the latest cars, household appliances, and cellular phones, demonstrates the international quality of the modern capital. In addition, the increasing use of satellite television and the internet further links Ethiopia to the rest of the world.

For most of its history, Ethiopia has been ruled by a king or emperor. However, during the revolution of 1974, Emperor Haile Selassie (reigned 1930–74) was deposed, resulting in the transformation of the Christian kingdom into a secular republic. Another major event in modern history with profound consequences for Ethiopia was the secession of Eritrea, a region that was one of Ethiopia's fourteen provinces until it seceded *de facto* in 1991, and *de jure* in 1994. Culturally and economically, however, Ethiopia and Eritrea remain very much linked, and what is written here of Ethiopia is generally true of Eritrea, especially the specific culture of the highlands.

The name "Ethiopia" comes from the Greek word *Aithiopes*, first used before 700 B.C. to describe the country of dark-complexioned people living south of Egypt. This name was prevalent in the West long before it was adopted locally, and it originally referred to any region inhabited by black people. As such, its significance in antiquity relates to historical accounts of black people in general, including, obviously, the inhabitants of the region of today's Ethiopia. As black people dominated Africa, the term "Ethiopian" was used to refer to all people of the

Fig. 5

Aksum is dominated even today by large ceremonial stelae, or memorial monuments, that stand as *tour-de-force* examples of early stone carving of the 2nd–4th centuries

continent, and particularly to people in the sub-Saharan regions. Ethiopia's position as the only country in sub-Saharan Africa to accept the Bible before the arrival of western missionaries probably contributed to its becoming specifically associated with the name. As for the "Ethiopians" themselves, in antiquity they called their country Beḥerä Ge'ez, "The Land of the Ge'ez," Ge'ez or Ag'aziyan being the name of the people who developed Ethiopian script and Ge'ez or Ethiopic literature.[1] It is not documented when Ethiopians adopted the name Ethiopia for their country.[2]

Prior to World War II, the West referred to Ethiopia as Abyssinia, Abyssinie, Abissinia, or Abessinien. Although it is generally agreed that this name is the western version of Habasha, or al-Ḥabaśah, the name used in the Arab world for Ethiopia, the linguistic process that generated it is not clear. Although the name Habasha is known to Ethiopians, interestingly, it is used locally to refer to the people, not to the country. Today, there is a tendency to stay away from the term altogether, due to the belief that it does not include Ethiopians of the south and southwest and the incorrect assumption that it has a derogatory connotation in Arabic. Still, Ethiopians will casually describe their cultural products by it, referring, for example, to a Habasha costume, a Habasha dish, or Habasha music.

With respect to its ethnic, religious, and linguistic diversity, the Italian scholar Conti Rossini is widely quoted as calling Ethiopia "a museum of peoples."[3] Conti Rossini made this observation in the 1920s after years of anthropological study of the country, especially the languages of its inhabitants. Ethiopia's diversity is primarily a result of two forces—commerce and nation-building—both of which worked to bring the region's diversified inhabitants together as one nation. Since ancient times, merchants transported goods into the interior of the Horn of Africa, especially salt, beads, textiles, and richly decorated umbrellas for church processions. They left with local export "goods," including gold, ivory, and slaves. And, at every opportunity, kings and their armies followed the trail of the merchants and pushed the frontiers of their kingdom outward to enlarge the population that would pay them tribute in the form of cattle, grain, gold, and manpower.

Religious diversity was enhanced by Christian monks, who were active in attracting new members to the Church at the expense of indigenous religions.[4] It is also likely that natural catastrophes, such as recurrent drought, caused the large-scale migration of peoples in and out of the region, which over time left the country populated by a variety of ethnic groups.[5] Because of this continued interaction, and unrestricted mixing through marriage, Ethiopians are now at a stage where Conti Rossini's "Ethiopia is a museum of peoples" could be rephrased as "each Ethiopian is a museum of peoples."

There are approximately seventy-five distinct languages spoken in Ethiopia, some of which also have regional variations or dialects. Linguists generally place the languages of the ethnic groups into one of three categories: Cushitic, Semitic, and Nilotic. There is no physical difference of any significance between the "Cushites," who are akin to the people of North Africa, and the "Semites," about whose culture we hear more than that of any other ethnic group of Ethiopia. Their languages, too, are sufficiently related to one another for scholars to group them into an Afro-Asiatic or Hamito-Semitic branch of world languages.[6] "Cushites" settled in many areas of

Ethiopia, while the "Semites" settled primarily in the north-central regions. The "Nilotes," by contrast, are darker skinned than members of the other two groups. And, as the name implies, they settled by or close to the river Nile, in the west.

As for modern-day Ethiopia, according to the most recent census, taken in 1994–96, it is home to approximately 53 million people (though this number may be closer to 60 million today). Approximately 62% of the population is Christian, of which 51% are members of the Ethiopian Orthodox Church, 10% are Protestants, and 1% are Catholics. Of the rest, 32% of the population is Muslim, 5% belong to traditional religions of African origin, and the remaining 1% comprises Hindus, Jews, Bahais, Jehovah's Witnesses, and atheists. Generally speaking, Christianity is at home in the provinces of the highlanders (the Amhara and Tegreans), notably in Tegray, Begemdir (Gondar), Gojjam, and northern Shoa, while Islam is embraced by the lowlanders (Somalis, Afars). Christianity has been the religion of the Amhara for centuries. The number of Muslim Oromos is more or less equal to that of Christian Oromos. Harar, Arsi, Bale, Kaffa, and Illubbabor are the homes of Oromo Muslims. Native African religions are mostly followed in the south and west.

Today, the most dominant cultures are those of the Oromo and the Amhara. Approximately 30% of the population claims to be native Amhara and speak Amharic, and another 30% identify themselves as Oromo and speak the Oromo tongue. The culture of the Oromo has been influential due to the sheer number of Oromo speakers and their presence in the central, eastern, southern, and southwestern areas of the country. The dominance of the Amhara culture is to be found in the widespread use of Amharic, which has been the state and inter-ethnic language at least since 1270, the beginning of the Solomonic dynasty. In fact, though the syllabus of the traditional education developed by the Ethiopians of the central and northern highlands has been preserved in the written language of Ge'ez (which ceased to be spoken in the twelfth or thirteenth century), in all provinces, the spoken language of instruction has been Amharic, regardless of the linguistic background of the teacher or of the students.

Daily Life

Traditional village life is patriarchal in nature and is organized around families in which the husband is the head. Respect for the elderly, for parents, and for teachers is fundamental to the social fabric, and children are taught at an early age to show complete submission and obedience to these prominent members of the community. Conflicts or problems both within families and between families are mediated by *shimaghilles*, elderly men who have won respect in society due to their age and experience, and who are fixtures within Ethiopian culture. In the event of a dispute, people go to court only if they fail to settle their differences through the intervention of impartial *shimaghilles* chosen by the two parties.

Marriage is carried out by arrangement, as Ethiopians believe that this is proper under biblical teaching (Genesis 21:21; 24; and 28:2). The boy's parents send *shimaghilles* to the parents of the chosen girl to ask them to give their daughter in marriage. Before the *shimaghilles* accept the assignment, they make thorough inquiries to determine whether there is any blood (or spiritual) relationship

between the boy and the girl, as traditional taboos prohibit blood relatives who are not at least seven generations apart from marrying.

If the girl's parents consent, a wedding date is agreed upon at a betrothal ceremony, during which the boy's family gives the dowry for the bride-to-be to her parents. Ample time is provided for the preparation of the spices to be used in the wedding feast, and for brewing the beverages, such as the *täjj* (honey wine) that will be served to the wedding guests. As she has not been consulted, a girl who is to be married may only find out what is in store for her when she notes the commotion in her family or hears her peers in the village talk about her future when they go together to the river to fetch water. Her parents traditionally would not tell her of the planned wedding out of fear that, if she knew, she might run away in order to escape the marriage. The notion that a girl would resist marriage also manifests itself in the practice of cutting the girl's nails on the eve of the wedding, in order that she not hurt the bridegroom when she, as part of the tradition, resists his advances on their first night together.

In the afternoon of the day of the wedding, the bridegroom and his best men come to the bride's house to feast and to collect the bride. Tradition requires that the bride's family and friends, in particular the singing girls and boys at the party, wait for the bridegroom's entourage; they are then ready to sing insulting lyrics to the new arrivals, as if they were intruders coming to take away the bride against her family's will. The bridegroom's company in turn dances and sings retaliatory songs. It is an occasion for the two families to brag about the bride and bridegroom, and for each to claim a higher social status than the other:

"Do you not feel the pride that you are the daughter of ...!"
"Do you not feel the pride that you are our daughter!"
"Do you not feel the pride that you belong to us!"

If one of the best men is not ecstatic with joy in dancing and singing and sprinkling perfume, the bride's party will insult him in song:

"Drag it, my cat, drag it away, there is a corpse in my house!"
"What happened to the best man? We do not know where he is!"

Towards the end of the evening, after the wedding feast, the bride is sent off with the bridegroom and his party with a song that reminds her that she is expected to be found a virgin:

"Your *tchagwla* has blossomed; your *tchagwla* has blossomed,
Oh our sweet one!"
"Your *tchagwla* has blossomed; your *tchagwla* has blossomed,
Oh our moon!"

Tchagwla, the counterpart of the Jewish *Huppah* (Psalms 19:5), is the nuptial chamber where the bride will lose her virginity. At the bridegroom's house, the young members of the party dance, singing, "The victory! O yes, the victory is going to happen tonight!" The good news from the *tchagwla* chamber is brought in different forms, such as the sound of a gun shot by the bridegroom bragging of his prowess in defeating his "sound" bride, and is a source of joy to the guests at the party, who prefer not to disperse until they hear it.

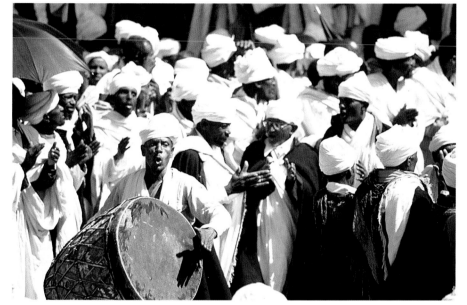

Fig. 6
A scene of celebrants and clerics dancing and beating drums outside a church in Gondar

Until very recently, it was a part of the wedding ritual for the bridegroom's best men to go to the house of the bride's parents early the next morning singing and dancing and carrying on a pole, like a flag, the piece of the cloth stained by the blood from the *tchagwla* chamber. The sight of the "flag" and the victory song of the messengers would bring relief to the girl's parents, as a girl who is not a virgin would bring shame to her family. In fact, a non-virgin could be returned to her family the next morning (see Matthew 1:19) by the groom's family, who might also demand a refund of the dowry. Under these circumstances, many parents elected to have their daughters marry at an early age, often even before they became teenagers.

Although non-church marriages are generally against religious teaching, most marriage ceremonies are, in fact, performed outside the church. The church insists only that priests and deacons marry in a church, and couples married outside church are not excluded from membership. Couples may renew their Christian marriage at any time, not by participating in a marriage ceremony, but by taking Holy Communion together.

Once married, women usually find themselves in traditional arrangements in which the man is the head of the household. This relationship is manifested by the way husbands and wives address each other. While men may address their wives directly by name, women do not

address their husbands in this manner. Rather, until they have a child, a woman always refers to her husband as "he." After a child is born, she will then address him as "the father of...". In addition, while she does not take her husband's family name, as is customary in the West, the wife is given a new name chosen for her by her husband, his best men, and his family.

Division of labor is strict; violation of this arrangement, especially by the husband, is shameful. The husband is the breadwinner of the family, while the wife is in charge of the kitchen, the bakery, and the brewery. One important exception to Ethiopian patriarchy is found in the rights of Amhara women. Despite the fact that they are not allowed to choose their husbands, they are considered equal to their male siblings with respect to inheriting their parents' property, and, in the event of divorce, are entitled to claim half of what the couple earned during their life as husband and wife. This is not true of most of the other ethnic groups.

The naming of a child is also an important event and, among the traditionally educated class, involves meetings with local experts trained in the art of consulting the zodiac. In addition, tradition requires that parents be careful not to offend a relative or a close friend by claiming his/her name for their child. A person has one name only, his/her personal name. It is followed by the name of the father to distinguish him/her from others with a similar name. The phrase "son of" or "daughter of" is not used (as in the Arabic and Jewish tradition) but is implied.

Children also receive a baptismal name. Baptismal names take the form of "servant of...," "son of...," "daughter of...," "maiden of ...," "image of...," "word of...," "beauty of ...," "plant of...," "body of...," "fruit of...," "compassion of...," and so on, followed by the name of a saint, such as Mary, George, Michael, Gabriel, Anne, or one of the names of the Son of God, such as Jesus, Christ, Savior, or Emmanuel. Orthodox Christians consider it arrogant, even blasphemous, to give a child the name of the Blessed Virgin (Mary), the Savior (Emmanuel, Jesus, Christ), or the holy archangels (Michael, Gabriel). However, this tradition is now changing due to western, especially Protestant, influence. Baptismal names, known usually only to members of the family and the priest, are used only when one prays on behalf of the person on certain occasions, such as when a ritual—the unction of the sick, the ceremony of matrimony, or a funeral rite—is performed for that person.

An important tradition that accompanies the birth of a child is circumcision, which is practiced on both boys and girls. With respect to girls, the practice would appear to be another example of the intersection of traditional African customs (it is widespread in neighboring Islamic communities) and the newer Judeo-Christian influences. In any event, those who oppose "genital mutilation," as the circumcision of girls is called in the West, find change slow in coming because parents who choose to have their daughters circumcised consider the practice an important part of their culture. There is an untenable belief that the Old Testament (Genesis 17:12) orders the practice for both genders.[7]

Gender issues also play a key role in the traditional education system. First, reflecting the general societal bias, schooling has traditionally been reserved almost exclusively for boys; girls have to be married while still of school age. Second, because classes are conducted in church courtyards and monasteries, which are usually located far from the scattered houses of the countryside,

even most boys have a difficult time traveling to these institutions or meeting the expenses of an education. While the system is well developed, formal education has generally been inaccessible to most Ethiopian families. There are no fees, but there are expenses for the food and clothing that students need.

Those who do go to traditional schools generally begin at the elementary level (the only stage available to girls) with just one teacher. Students are required to help each other; the alphabet is taught to new students by the students who have graduated to the next level, which involves learning how to read the first chapter of the First Epistle of Saint John, followed by the Gospel of Saint John, all in Ge'ez, a language that the child does not understand. The next level involves learning how to read the Psalter, taught by the head teacher.

These lessons are conducted during the day. Students spend the evening (and the night) at school studying and memorizing the standard prayers to God and the hymns of praise to God and his saints, and especially to the Blessed Virgin.

Elementary education is completed when the pupil is able to read the Ge'ez Psalter fluently. Interestingly, students who complete elementary education will have mastered the traditional pronunciation of Ge'ez texts even though they do not understand what they are reading.

Male students may continue on to Ge'ez language school, known as *qene bet*. Here, students study the Ge'ez language—its grammar, vocabulary, and the art of composing the Ge'ez poems, or *qene*, after which these schools are named. Tradition very clearly and strictly defines the styles of each of the various types of *qene* poems, specifying the proper number of lines and the music assigned to each.

Following *qene bet*, a student may go to a *mäṣḥaf bet*, a school where he studies the interpretation of the Old Testament, the New Testament, or the canon laws, or he may decide to go to *zema bet*, where he learns by heart the voluminous liturgical texts for the year and how to sing them. As these schools of higher learning are located in different provinces of the country, it has always been difficult for students of one region to attend a school located in another, particularly since the roads along which students must travel are fraught with danger from wild animals, floods, and possible disease in the villages through which they pass. On the other hand, being required to travel to distant schools gives students from different parts of the country and varied ethnic backgrounds the opportunity to see the entire country and its people, and to inherit a common education.

Students who pursue their education beyond the elementary level can aspire to become teachers or the heads of important churches, which have had large estates granted to them by the government (i.e., the monarch) and by the rich. Most students, however, stop with an elementary-school education. Interestingly, this level of education is generally considered adequate preparation for service in government departments as clerks and archivists in Amharic. These students are also qualified to learn how to sing in church rituals and to serve as parish priests.

The church rituals performed for the dead, as in all cultures, are among the most important duties of the parish priest. The funeral ritual, which takes place as soon as possible after death, involves a church procession that

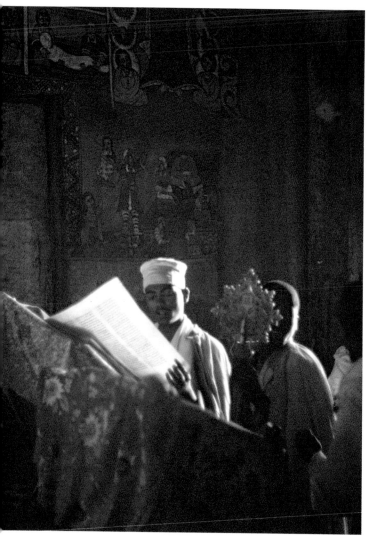

Fig. 7

Clerics standing behind an altar, one reading from a holy text, the other holding a processional cross

takes the body to the burial site, usually near the parish church. Mourning involves the entire family, which provides food and drink for the clergy as part of the procession. Known as the *täzkar*, or "feast of commemorating the dead," this feast can be rather expensive. Professional mourners, in exchange for a fee, sing lyrics of mourning. People cry out loud when the singers recount in song the dead person's virtues, and regret the fact that the person will soon be food for the earth and the worms— "that beauty will soon be eaten by the dirt; that hero will soon be food for the worms!"

People attending the service afterward accompany the family members of the deceased to their house while the clergy stay behind to help themselves to food and drink. Other relatives and close friends spend the evening with the mourning family, and some even stay through the following three nights. Early on the morning of the third day, mourners go to the burial place and cry afresh for the dead. The deceased is commemorated with special prayers and feasts on the third, fortieth, and eightieth days following the date of death, and once a year for at least seven years. Part of the food from these gatherings is taken to the clergy who prayed for the dead. The deceased's will becomes public at the feast of the fortieth day.

Religious Practices

Tradition maintains that Ethiopians worshipped God according to the Jewish religion until the fourth century, at which time they accepted Christianity. The story of the founding of the Christian faith in Ethiopia, recounted below, is particularly fascinating. While scholars have debated the extent to which this history is accurate or

verifiable,[8] what is clear is that the religious practices, secular culture, and daily life of this particular group of Ethiopians reflect clear Judeo-Christian influences, layered atop a stratum of traditional African life, particularly in the areas of social organization, family life, art, and architecture.

The story of the founding of the "Judeo-Christian" Kingdom of Ethiopia is preserved in an important book called *Kebrä Nägäśt*, or "Glory of Kings."[9] The teachings of the *Kebrä Nägäśt* form the basis and spirit of the governing principles of this religious-led country, and is to Ethiopians what the Torah is to Jews and the Qur'an is to Muslims. The strength of the story and spirit of the *Kebrä Nägäśt* has sustained Ethiopian Christianity, despite centuries of isolation from the rest of the Christian world. Indeed, the power of this tradition was probably a major reason for the survival of Christianity in central Ethiopia when Islam was spreading in other parts of the country, as it had elsewhere in the region.

The central teaching of the *Kebrä Nägäśt* is that God selected the people of Ethiopia to replace the people of Israel as his chosen people. According to the *Kebrä Nägäśt*, Ethiopian Christianity is a continuation, rather than a rejection or replacement, of Ethiopian Judaism. In keeping with this teaching, Ethiopians treat the Old Testament and the New Testament with equal reverence and claim to see no difference in the value of the two texts. As evidence, they quote the *Synodicon*, the collection of the church's canon laws, which says, "the former tells about the latter, and the latter completes the former."[10]

The *Kebrä Nägäśt* points to two specific "facts" in support of the general claim that Ethiopians are God's chosen people. The first is that Ethiopians have the Ark of the Covenant, which the Israelites lost to them, and the

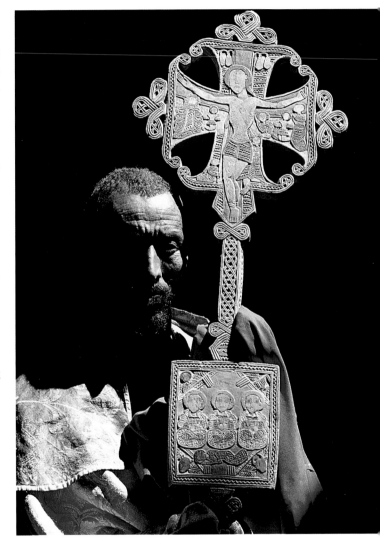

Fig. 8

Cleric holding a carved, wooden hand cross

second is that Ethiopians have accepted the expected Messiah (Jesus Christ), while the Israelites have rejected him.

The book narrates the story of Ethiopian Judaism and its transition to Christianity in the language of romance, suspense, duplicity, and adventure. The protagonists are Makedda, the Queen of Sheba (according to I Kings 10 and II Chronicles 9), also known as the Queen of the South (according to Matthew 12 and Luke 11); Solomon, King of Israel; and Menilek, their son. According to the book, "South" as used in the Gospels refers to Ethiopia. The story begins with Queen Makedda/the Queen of the South journeying to Jerusalem to visit King Solomon to witness firsthand his widely acclaimed wisdom. On one of the nights she spends in his palace, Solomon tricks his royal visitor into accepting the divinely ordained advances he makes toward her. She returns to her kingdom converted to Judaism and pregnant with his child. While on her journey back to Ethiopia, she gives birth to a handsome boy, who looks exactly like his father. She names him Menilek, meaning "Son of the Wise Man."

When Prince Menilek reaches the age of maturity, he travels to Jerusalem to visit his father. King Solomon is pleased to see his son and asks him to stay in Jerusalem as the heir to his throne; Menilek, though, prefers to return to Ethiopia. When Solomon realizes that he cannot convince Menilek to stay in Israel, he orders the first-born sons of the Israelites and a few prominent men of law to accompany Menilek to Ethiopia to help him restructure his mother's kingdom on the model of the kingdom of Israel. These Israelites grudgingly accept their king's order, but do not want to live apart from the Ark of the Covenant. So they steal the Ark, leaving a replica in its place, and depart for Ethiopia, the future Zion, with their new leader. Solomon

does not become aware of the theft until Menilek and his people are beyond his reach.

Interestingly, the names of the Israelite men of law, the Ethiopian provinces in which Menilek appointed them to positions of authority, their ranks, and the annual tribute they and their heirs bring to the king are all recorded in the *Kebrä Nägäśt* and the Royal Chronicles of Ethiopia. The Solomonic dynasty, which began its rule in the thirteenth century, even takes its name from the legend of Menilek, as these kings claimed direct descent from King Solomon and the Queen of Sheba.

The first western authority to document the founding of Christianity in Ethiopia is Rufinus, a fourth-century historian.[11] Rufinus claimed to have heard the story described below from Aedesius, a participant in the events, but Rufinus confused Ethiopia with India. According to Rufinus, a teacher from Tyre (in Syria) traveled by boat to distant countries on the Red Sea (and the Indian Ocean). With him were two of his students, Frumentius and Aedesius (locally also called Sidrakos). When the vessel anchored in an Ethiopian port, the travelers descended to visit the region as planned, or "to procure some necessities." Unfortunately for the voyagers, the treaty of friendship between their country and Ethiopia had been abrogated some time before their arrival. The coast guards, therefore, attacked the intruders and killed all except Frumentius and Aedesius, whom they took to the king. The king made Frumentius his secretary and Aedesius his cupbearer.

Frumentius and Aedesius served the king for many years, and he freed them from his service just before his death. But the queen dowager asked them to stay to assist the crown prince until he came of age. They agreed to remain in Ethiopia, and Frumentius was given a high

position in the administration of the kingdom. This gave Frumentius, who was interested in spreading Christianity, the opportunity to seek out Christian merchants (from the Mediterranean world) in the city. He located and made contact with a number of such merchants and encouraged them to build an oratory with a school attached to it.

When the crown prince reached maturity, Aedesius and Frumentius left Ethiopia. Aedesius returned to Tyre, where he apparently encountered Rufinus and related his experience. Frumentius, for his part, traveled to Alexandria to report to its archbishop, Athanasius (295–373), on the state of Christianity in the Ethiopian kingdom. Frumentius begged the Archbishop to send a bishop and clergy to Aksum, the capital city of Ethiopia at that time, to water the seed of Christianity that he had sowed.

Athanasius offered the bishopric to Frumentius himself, declaring: "What other man shall we find in whom the Spirit of God is as in thee, who can accomplish these things?"[12] Frumentius accepted the offer and returned to Ethiopia as its apostle. In his bishopric, he built many churches and "performed various miracles, healing diseases of the souls and bodies of many."[13] The *Synaxary*, the book of the saints of the church, states that as a bishop, Frumentius was renamed Abba Sälama the Illuminator.[14] Whatever the truth of the Rufinus narrative, it has been independently verified in a fourth-century letter that Frumentius served as a religious leader in Ethiopia during this period.[15]

It is interesting to note that since the time of Frumentius, the Ethiopian Orthodox Church, the soul of the theocratic Ethiopian kingdom, has been closely linked to the Coptic, or Egyptian Christian, Church of Alexandria. In fact, it was brought under the jurisdiction of the Coptic Church during that time and did not become independent until 1951. Therefore, like the Coptic and the other Eastern Orthodox churches, known in western religious circles as the Monophysite churches, the Ethiopian Church accepts the Councils of Nicea (325), Constantinople (381), and Ephesus (431), and rejects the Council of Chalcedon (451). In light of this history, the influence of Coptic Christian literature on the thought processes of the Ethiopian clergy has been immense. Yet, there are significant cultural differences between the two churches, the most important being the Judeo-Christian and sub-Saharan African aspects of the Ethiopian Church.

As an aside, the traditional story regarding the introduction of Islam into Ethiopia is equally interesting.[16] According to Islamic tradition, the prophet Muhammad's propagation of a new religion in the Arabian Peninsula did not please the leaders of Quraish, the Prophet's tribe, who worshipped several gods. His incipient movement, which proclaimed "No godhead other than God," immediately came under attack by these leaders. Muhammad and his followers believed that the Christian king of Habasha (Ethiopia), a neighboring monarch, would provide them with a safe haven if they sought refuge in his country. In the face of persecution from local leaders in Arabia, the Prophet (who reportedly was breast-fed by an Ethiopian woman as an infant) addressed his followers: "If ye went to the country of the Abyssinians, ye would find there a king under whom none suffereth wrong. It is a land of sincerity in religion, (go hither and stay there) until such time as God shall make for you a means of relief from what ye now are suffering."[17]

Over 130 refugees, including one of the Prophet's daughters and her husband, fled to Ethiopia. There they

"were allowed complete freedom of worship."[18] But their persecutors followed them, bringing with them gifts (bribes) for the influential nobility in Ethiopia. The persecutors claimed that they, as the relatives of the refugees, knew what was best for them and put pressure on the king to hand over the refugees. The king, however, refused, saying, "Nay, by God, they shall not be betrayed—a people that have sought my protection and made my country their abode and chosen me above all others! Give them up I will not!"[19] Ultimately, realizing the danger the refugees faced, the king accorded them his protection. When the persecutions had ended, he provided them with boats for their safe return voyage.

This same tradition maintains that the king, pleased and satisfied with the outcome of his inquiry about the refugees and their religion, converted to Islam. However, there is no internal evidence that Ethiopia had a Muslim monarch at this or any other time in its history. Nevertheless, Islam has spread steadily in Ethiopia from the seventh century onward, though at not as dramatic a pace as in neighboring countries, such as Egypt and the Sudan.

Guided by the *Kebrä Nägäśt* and its underlying Judeo-Christian tradition, Ethiopian Christianity was firmly established in the central highlands by the fifth century and reinforced by the ruling monarch. The close ties between Church and state became even more firmly established under Emperor Zär'a Ya'eqob (reigned 1434–68), who instituted the mandatory veneration of Our Lady Mary and her icon. With respect to non-Christian communities, the existence of a Christian overlord was, not surprisingly, often the source of conflict. As a relatively small community located amidst a sea of other religions, Christian Ethiopia has alternately struggled for survival against the pressures of outside forces and aggressively fought to incorporate neighboring communities into its kingdom. But Islam does not tolerate its adherents to be ruled by an authority of another faith: Islam is both religion and state. Therefore, within Ethiopia, adherents of Orthodox Christianity and Islam, the two dominant religions in Ethiopia, sought to dominate each other for centuries. As one might expect, their struggles to control the state were detrimental to the country in every respect. The most significant of these conflicts was the full-scale war that erupted in 1527 and lasted fifteen years, involving the Ottoman, or Turkish, Muslims on the side of the Muslims and the Portuguese Catholics on the side of the Christians.[20] The loss of human life and the destruction of the country's cultural heritage and economy were devastating. In the end, the Christian monarchy did survive, but the damage to the country was irreparable.[21] Following these events, in 1636, the Ethiopian capital was moved from the Shoa region to the western city of Gondar, further away from the Muslims to the east.

Notwithstanding these conflicts, however, the several Islamic communities remaining within the boundaries of the Ethiopian Christian kingdom did live peaceably with their Christian neighbors for long periods of time. Critical to their coexistence was the fact that the Christian monarch's authority over these Islamic and other communities was clearly defined and severely limited. Especially in the Middle Ages, these communities formed autonomous states within the state, governed by their own religious and ethnic leaders. The Christian monarch did not interfere in their internal affairs as long as the Islamic leaders demonstrated their loyalty to him by paying annual tributes and, as a sign of allegiance, occasionally

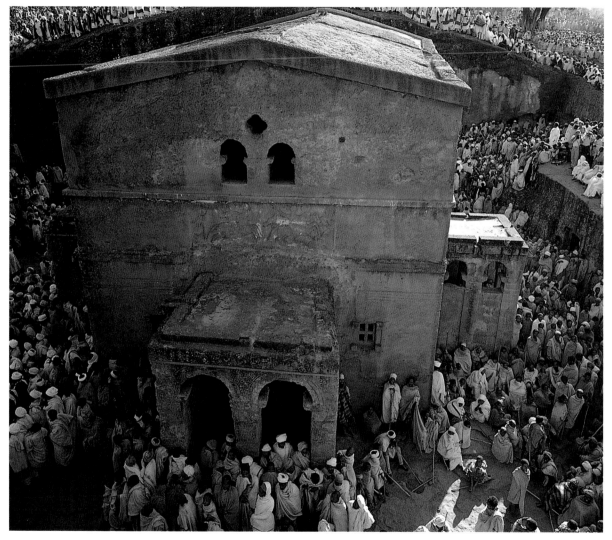

Fig. 9

During large celebrations at Lalibala, the
priest and the congregation surround
the 12th-century church of Saint Mary to
chant and sing in praise of the saints

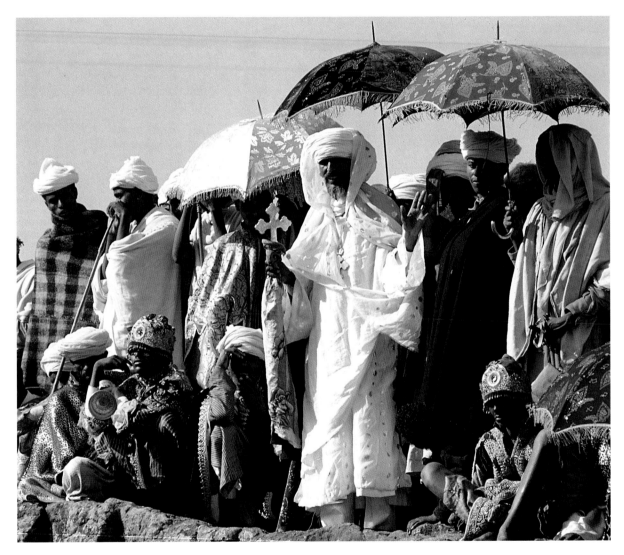

Fig. 10

Members of a church congregation carry colorful, embroidered umbrellas as they gather on either side of the cleric, who is dressed in white and holding a cross

bringing him presents. The monarch titled himself "King of Zion and King of Kings of Ethiopia," Zion referring to the Judeo-Christian territories of his realm, which he ruled through governors whom he could appoint and demote at will. The non-Christian communities, including the Beta Isra'el (Falasha or "Ethiopian Jews") were autonomously ruled by their hereditary governors.

Within the Christian community, religion has informed virtually every aspect of life. For example, dietary habits are strictly as prescribed in the Old Testament:

> These are the beasts which ye shall eat among all the beasts that are on the earth. Whatsoever parteth the hoof, and is clovenfooted, and cheweth the cud, among the beasts, that shall ye eat. Nevertheless these shall ye not eat of them that chew the cud, or of them that divide the hoof: as the camel, because he cheweth the cud, but divideth not the hoof; he is unclean unto you (Leviticus 11:2–4).

The next verse tells that the rabbit, the hare and the swine are considered unclean because they do not meet one of the two requirements. Furthermore, as "Israelites," Christians, at least the Amhara Christians, do not eat shulleda, the Amharic word for sinew. They avoided shulleda as, according to the Bible, they should not eat "sinew which shrank, which is upon the hollow of the thigh, unto this day: because he [the Lord] touched the hollow of Jacob's thigh in the sinew that shrank" (Genesis 32:32).

Also religious in nature are the most important holidays observed in the Ethiopian calendar. The Ethiopian calendar divides the year into twelve months of thirty days each, plus one "month" of five or six days. The first day of the Ethiopian year falls on Mäskäräm 1, which corresponds with September 11 (12 in a leap year). Before the reformation of the Julian calendar by Pope Gregory XIII in 1582, New Year's Day fell on August 29. The Ethiopian year and the Gregorian year are seven to eight years apart.

Although New Year's Day is a national holiday, each family observes it privately. Families traditionally slaughter an animal, such as a heifer or a lamb, and come together for a private feast. The only exception to this is that the young girls of the village or neighborhood usually gather together and go from house to house singing the traditional New Year's song and carrying flowers, for which they are rewarded with money and food.

The first feast of the year that is celebrated communally is Mäsqäl, the day of the finding of the True Cross of the Crucifixion by Queen Helena, mother of Emperor Constantine the Great (reigned 306–37). The holiday is commemorated on Mäskäräm 17, that is, September 27 or 28, but the ceremony begins in the afternoon of the eve with the Dämära, or "piling," of firewood in a special way at the public square. On Mäsqäl day, the piled wood is blessed by the highest ecclesiastical authority in the presence of the celebrating faithful, including the highest church and state officials, and is kindled by the monarch or, in other communities, by his representatives.

In addition to the finding of the True Cross, Mäsqäl is also an occasion to celebrate the end of the rainy season. Indeed, some of the songs that are sung on the occasion are expressions of joy that the rainy season is over. The heavy rains of the highlands keep the Ethiopian world at a standstill from June to September, and after Mäsqäl life resumes, as travelers can cross local rivers and move around the region.

The next feast that is celebrated communally is *Ṭemqät*, on *Ṭerr* 11, or January 21 or 22, the day on which Christ was baptized. The ceremony begins in the afternoon of *Ṭemqät* eve with the *Kätära*, or "damming," of the river for the water needed for the ceremony. Throughout the afternoon, the clergy of each church in the area arrive at the designated local river, in a remarkable procession in which they carry their *tabots* (replicas of the Ark of the Covenant), processional crosses, and sacred icons. Each party is accompanied by the faithful of its parish. The clergy pitch their tents by the river and spend the night there. Mass and prayers to bless the water start very early in the morning. If more than one church participates in the ceremony at any particular river, the churches take turns leading the prayers in different years. Officials of the state and other guests start arriving around 9 a.m. The water is again blessed by the supreme head of the church, after which the faithful are allowed to immerse themselves in it. This immersion is not a renewal of their own baptism but a revered commemoration of the baptism of Christ. Following the ceremony, the clergy return to their churches, while many of the people stay until evening, singing and dancing.

The feast of the Transfiguration (see Matthew 17:1–13; Mark 9:2–13; and Luke 9:28–36), known popularly as *Buhe*, is celebrated on *Nähase* 13, or August 19. This annual feast is much anticipated by the young men of the villages. On the eve of *Buhe*, families light torches made of dry twigs in front of their houses. Later, young men of the village come together and visit the houses of the neighborhood, singing and dancing. They are rewarded with money and special loaves of bread prepared for the occasion. They make long whips, which they crack by twisting the tip of the whip while holding the wooden handle attached to its other end. They also use the whips to fight "duels."

Christmas is celebrated on *Taḫśaś* 29 (28 in leap year), or January 7 (or 6). This holiday is a serene feast for the elderly, who generally attend church and, upon their return, enjoy (with the rest of the household) a special meal prepared for the occasion. It is a tradition for people to deliver holiday wishes in person to acquaintances of social status, generally people of old age and high rank. Young men play the game of *genna*, which looks like hockey and more often than not ends with the losing party starting a fight. If participants are hurt, tradition has it that they have no recourse and can only lick their wounds. The saying is "the master [i.e., the head of the family] will not be angry at incidents taking place during *genna* games."

Easter is the most prominent of all the feasts of the Ethiopian Christian calendar. As in the West, it is a movable feast related to the Jewish Passover and usually falls in the month of April. During Passion Week, but especially starting on Maundy Thursday (feast of the Last Supper), churches and their compounds are packed with worshippers. On Good Friday, the faithful are absolved of the sins committed during the year by making confessions to the priest, who walks among the attendants in the churchyard. The priest gives them a penance in the form of a given number of *segdät*, or prostrations on the ground. Not only confessors perform *segdät*, however. On Good Friday, everyone performs *segdät* an average of one hundred times. The general view among the faithful is that there may be sins one does not remember, or has conveniently forgotten, which require self-imposed

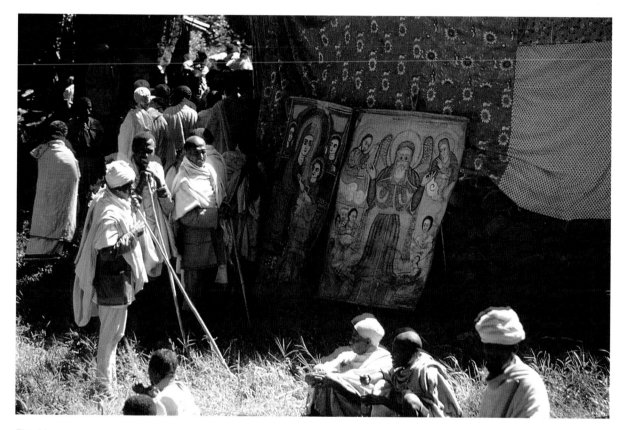

Fig. 11

Icons displayed for
veneration outside a church
near Addiet (south of Lake
Tana) on the feast day of
Saint Zara-Buruk

punishment. Moreover, the most religious do not eat from Friday morning until the Resurrection Mass is over in the early hours of Sunday morning.

In addition to these major holidays, the Christian calendar is marked by numerous fast days, which are generally strictly observed. Fast days include Wednesday and Friday of each week (except during the period from Easter until Ascension), as well as the annual Fast of Nineveh (three days, in memory of God's mercy on the people of the city of Nineveh, who observed Jonah's call to repentance; Jonah also spent three days in the belly of a great fish). There are also the Fast of Lent (fifty-five days before Easter), the Fast of Advent (forty days before Christmas), the Fast of the Apostles (forty days after Ascension), and the Fast of Mary (sixteen days before her Assumption into heaven). On fast days, the faithful forego breakfast and abstain from eating all animal and fowl products, including eggs. Fish, though not a common food in Ethiopia, is allowed during all fast days except the Fast of Lent.[22]

God and his saints are also honored through the custom of dedicating churches to them. Mary, the Mother of God, is the most revered and is known by several other names in the local tradition, including *Kidanä Meḥrät* (Covenant of Mercy), *Ledäta* (Her Nativity), *Bä'ata* (Her Presentation in the Temple), and *Qwesqwam* (the name of the place in Upper Egypt where the Holy Family sojourned during the Flight into Egypt). More churches are dedicated to Mary than to any other saint. One tradition maintains that several hundred years before Ethiopians accepted Christianity, the baby Jesus gave the Ethiopians to his mother to watch over as her special people. In the words of Emperor Zär'a Ya'eqob: "Listen, all of you, people of Ethiopia, men and women! You are prisoners for Mary

whom she received from her Son to be a tithe for her."[23] In each year, her devotees are expected to observe no less than thirty-three holy days in her honor.

Emperor Zär'a Ya'eqob is credited for Mary's prominence in Ethiopian Christianity. It was he who ordered the observance in her honor of most of the thirty-three feast days in the liturgical year. He also ordered the reading of her miracles, which number in the hundreds, at church services, along with related scriptural readings. Furthermore, he imported from the famous church in Old Cairo (called al-Mu'allaqah) a Marian ritual that was to be carried out before reading the miracle assigned for the day.

The holy days celebrated each month include the feasts of Gäbrä Mänfäs Qeddus (the founder of the Monastery of Zeqwala in Shoa), the Holy Trinity (in memory of the day God visited Abraham), Archangel Michael (for having helped people of God, starting with Joshua, on the 12th of each month), Archangel Gabriel (for announcing the birth of Jesus); George, the Martyr; Täklä Haymanot (founder of the Monastery of Däbrä Libanos in Shoa), the Savior of the World (for the day Christ was crucified), and the Son (commemorating the days Christ was conceived, born, baptized, and resurrected from the dead, all of which in the Ethiopian calendar took place coincidentally on the 29th of the relevant month). These feasts are celebrated by the faithful throughout the country. In addition, each region may honor a local saint whose feast day the inhabitants commemorate at least once a year. Hymns of praise composed to these and other saints constitute a large part of Ge'ez literature.

All of these holy days are observed in addition to the First Sabbath (Saturday) and the Christian Sabbath (Sunday), as they are respectively called in Ethiopia. Observing a

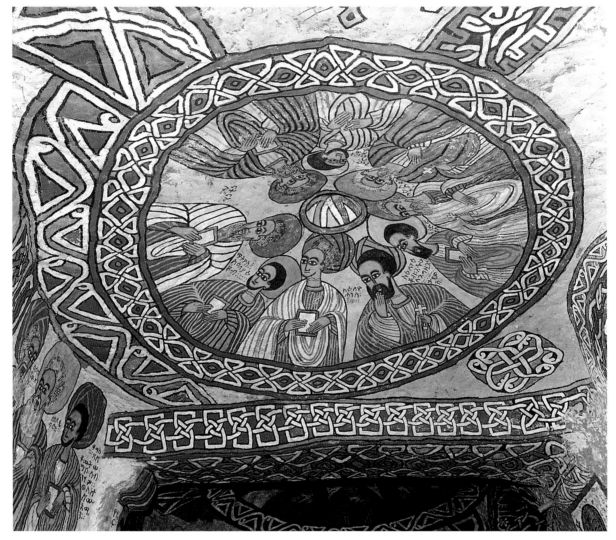

Fig. 12

Nine of the apostles, holding a book
or a hand cross, are painted on the
interior, southern dome of the
church of Enda Abuna Yem'ata, in
the province of Tegray

holy day means doing no manual work, not even fetching water from the river. It is, perhaps, understandable if people who work in the field feel that the workdays normally used for ploughing, seeding, weeding, and collecting the harvest are drastically reduced by these holy days. But the power of the saints, believed to work against the faithful who violate the observance of their memorial days, makes it difficult to ignore them. In addition to the church services held on holy days, regular church services are held each Sunday. Sunday Mass begins at around 6 a.m. and lasts approximately three hours. On fast days, Mass does not begin until noon, but the clergy are required to participate in other prayers before the general service. Church attendance has traditionally been quite high, especially on holidays.

During Mass, the Eucharist is broken on the holy ṣellat, or tablet. There is at least one ṣellat and a tabot, a box in which the ṣellat is housed, in every church. The tabot (with the ṣellat in it) is the Ethiopian equivalent of the Ark of the Covenant. Traditionally, the Ten Commandments were engraved on each ṣellat as a replica of the tablets Moses received on Mount Sinai. Today, an image of God or the saint to which the ṣellat and the church are dedicated may suffice. The ṣellat is ritually blessed by a bishop and is dedicated to a saint, who is thereby represented in the church. A church building becomes a church and a sacred place only if there is a ṣellat in it. The faithful believe that God resides in the tabot, just as in the Old Testament he resided in the Ark of the Covenant. As such, the tabot is the most holy object in Ethiopian Christianity. It is placed on the altar in the "inner temple," the inner-most of the three rooms of the church. The church building, with three circular walls representing the three rooms of the Jewish temple on the one hand and the African architectural tradition on the other, is a good example of the harmonious marriage of the two cultures in Ethiopian Christianity.

The taking of Holy Communion is a part of the Mass. In practice, however, only small children and the elderly receive Communion on a regular basis. Others stay away from it, because they fear the priest's warning that he pronounces during the service:

> He that is pure let him receive the Eucharist, and he that is not pure let him not receive it, that he may not be consumed by the fire of the godhead which is prepared for the devil and his angels. Who so hath revenge in his heart and who so hath in him strange thoughts and fornication let him not draw nigh.[24]

The priest then washes his hands before the congregation and continues the admonition:

> As I have cleansed my hands from outward pollution, so also I am pure from the blood of you all. If you presumptuously draw nigh to the body and blood of Christ, I will not be responsible for your reception thereof. I am pure of your wickedness, but your sin will return upon your head if you do not draw nigh in purity.[25]

It is generally understood that "purity" means, first and foremost, the avoidance of premarital or extramarital relations.

As all of the above would indicate, Christian Ethiopians are a very religious people, drawing guidance for the way in which they live their daily lives from the Bible and other religious texts. They believe absolutely in the existence of

a God whose authority no one can challenge. They fear his power because he is wrathful and vengeful if his commandments are violated, a trait associated mostly with the God of the Old Testament, and they are grateful to him because he is merciful if asked for forgiveness, a trait connected primarily with the Savior of the World, Jesus Christ. Ethiopians believe that to enjoy excessively what the world offers while others do not have enough is to violate God's will, and that God expects his people to lead an austere life. Monasteries and nunneries are the abode of the poor as well as the rich, who believe in the literal message of the Gospels, "For what is a man profited, if he shall win the whole world, and lose his own soul?" (Matthew 16:20), and "he that taketh not his cross and followeth after me, is not worthy of me." (Matthew 10:38). Monks are role models for the faithful, and monasticism is considered the highest form of Christianity, to which everyone, including heads of families, aspires.

By and large, religious law is based on the Bible, which for Ethiopians includes eighty-one rather than the sixty-six scriptures, the latter constituting the Bible used by Protestant churches.[26] The fifteen "additional" books, which include the books of Enoch, Jubilees, the two books of Esdras, and the three books of Maccabees, have been rejected by the Protestant churches, which refer to them as the Apocrypha. Although not included in the printed version of the Ethiopian Bible, the Church accepts the authority of the *Testament of Our Lord* and the *Apostolic Constitutions*, known as the *Synodicon* and the *Didascalia of the Apostles*.[27]

In addition to the scriptures, the writings of church fathers, such as Cyril of Alexandria and John Chrystostom, are also considered relevant to theological matters. The question as to whether some of the writings ascribed to these church fathers might not be authentic does not arise. Even locally composed eucharistic prayers are treated as authoritative, as if they were written by the church fathers to whom they are dedicated. One finds among these the *anaphoras* (eucharistic offerings) of Athanasius of Alexandria (295–373), the 318 Orthodox Fathers of the Council of Nicea (325), Gregory of Nazianzus (ca. 329–90), Gregory of Nyssa (ca. 335–95), and John Chrysostom of Constantinople (ca. 340–407). Homiliaries for the feasts of the saints, especially of the archangels Michael and Gabriel, Saint George, and the Blessed Virgin, are treated with great reverence.

Despite their deep religious convictions about God's role in their daily lives, Ethiopians also have a fatalistic view of life. They believe their fate is determined on the fortieth day after birth. Although this belief is held with respect to both men and women, the concept of the "fortieth day" could be related to the day boys are baptized (girls are baptized on the eightieth day following their birth). Fate also informs the name a child receives from his or her parents. The belief is that a child's name is chosen by an angel and is then whispered to someone, who in turn suggests it to the parents of the child. The name tells the child's future and how the child will behave as it grows.

Taking guidance from the signs of the zodiac, although condemned by the church, is also important to Ethiopians. A child's zodiac sign is related to his/her name, not to the month of birth. Another way of selecting names involves letters of the Ethiopian alphabet, which have numerical values known only to the "Book Opener." The "Book" in question is the *'Awdä Nägäśt,* or "Cycle of

Kings,"[28] in which the codes of the letters of the alphabet and the other divinations are recorded; the "Opener" is the diviner who is trained to open this book, i.e., read and understand the calculation. The numbers of the letters in a child's name as well as those in its mother's name are added together and divided by thirteen. The remainder (which would be between one and twelve) is the child's sign. When a child is born, the parents consult either each other or a "Book Opener," also called a "star gazer," if there is one in the neighborhood, about what the child should be called. *Mammo*, or "Baby Boy," and *Mammit*, "Baby Girl," serve as temporary names. On occasion, if the parents take too long to name a child, people become accustomed to using the temporary name, which then becomes the child's permanent name.

Traditional Ethiopian culture also asserts the importance of dreams. It maintains that God uses dreams to communicate with people in answering a prayer or in sending a message that something good or bad will happen. The roots of this belief appear to be found in the important role played by dreams and dream interpretation in the Old and New Testaments.

In the Old Testament, dream messages come hidden in compositions that can be interpreted only by experts (such as Joseph or Daniel, in Genesis 40 and 41, and Daniel 2 and 7, respectively). However, there are standard interpretations known to most Christians.[29] For example, a dove in a dream represents the Holy Spirit or a good person's soul, and a raven represents an evil spirit or a bad person's soul. A person who has a "good" dream enjoys a good day and anything positive happening on that or the following few days is believed to have been predicted by the dream. Conversely, people who have a "bad" dream have a miserable day and believe that any negative occurrences on that or the following days were predicted by the bad dream. It is believed, fortunately, that through prayer a person can prevent the bad events from occurring. One can also seek out another expert to obtain a different, and preferably more favorable, interpretation of the same dream.

For Ethiopians, religious books contain not only commandments to be obeyed and precepts to be observed, but also words that have protective and healing powers. These words are copied on a parchment scroll and carried on the body or read over water that is then drunk by or sprinkled on believers. In this way, the scrolls act as talismans against evil spirits or demons, sources of ailments and tragedies.

Another religious conviction that straddles the line between traditional African and Christian beliefs is the notion that God has secret names (*asmat*), which, if invoked in prayers, oblige the Lord to give a favorable answer with little or no delay. The evidence provided by practitioners is that Christ himself used such names, including the *talitha cumi* (Mark 5:41) when he healed the sick young woman and *Eli, eli, lama sabachthani* (Matthew 27:46) when he prayed upon the Cross. Ethiopic literature preserves the special prayers that the apostles, other saints, and worldly men of God supposedly used when performing miracles and fighting enemies. The idea that secret prayers exist for the faithful to use in their perpetual war against physical diseases and against other religious groups is very attractive.

The Church's teaching that magic and superstition are not consistent with Christianity does not seem to have fallen on many receptive ears. The clergy themselves to

Fig. 13

Demon (?), detail of a
prayer scroll, Ethiopia, 19th
century, ink on parchment,
58⅛ x 3½ in (151 x 8.8 cm),
W.845, Walters Art
Museum, gift of Gene
Guerny, 1997

this day secretly copy words (verses from the scriptures or made-up words and phrases) onto scrolls for people to carry as amulets to ward off evil spirits and the evil eye (called *buda* or *ṭayeb*).

The etymology of *buda* is unknown, but it is possible that it is related to the Hindu "Buddha," because *ṭayeb* is related to the Arabic *ṭabîb*, meaning "wise" or "a wise person." Wise and creative people, especially those skilled in pottery, weaving, tapestry, and woodwork, are said to have evil eyes. Children and attractive young people are warned to hide themselves from the eye of the *buda*, lest the eye "eat" them, that is, suck their blood by merely catching sight of them. It is widely believed that a *buda* changes into a hyena at night.

In the fifteenth century, Emperor Zär'a Ya'eqob wrote extensively against magical practices and took harsh measures against diviners and those who sought their counsel,[30] but neither his endeavors nor the teachings of the church have been able to liberate the faithful from the grip of these beliefs.

As this general overview of the history, customs, and practices of Ethiopian Christians shows, the central highland society is very Judeo-Christian in nature, though it does continue to reflect elements of traditional African practice that existed prior to the arrival of Christianity. Whether this culture resulted because Ethiopians were, as claimed in the *Kebrä Nägäśt*, Jews (i.e., adherents of the Jewish faith) before they accepted Christianity or because Ethiopians accepted the teachings of the Old Testament at the time they converted to Christianity, remains a question that scholars of Ethiopian studies will debate for years to come.[31]

Notes

1 Dillmann 1865 [reprinted 1970], col. 118; Getatchew Haile in *Le Muséon* 1982, pp. 312–13.

2 August Dillmann, a highly regarded scholar in the field of Ethiopian studies, maintains that Abyssinians adopted the name Ethiopia for their land and themselves in the Middle Ages, Dillmann 1879, p. 179.

3 Conti Rossini 1928, pp. 65–85.

4 Haberland 1965, p. 220; Haberland in *Journal of Semitic Studies* 9, p. 235; Kaplan 1984.

5 Conti Rossini 1928, pp. 65–85.

6 Cohen 1924, p. 24; Greenberg 1966, p. 42.

7 See Zär'a Ya'eqob's argument in Conti Rossini and Ricci 1964, pp. 154–65, 1965 translation, pp. 91–98.

8 Ullendorff in *Journal of Semitic Studies* 1/3, pp. 216–56.

9 Bezold 1909; Budge 1922.

10 Getatchew Haile 1992, pp. 107–9.

11 Migne in *Patrologia Latina* 1849, pp. 478–89; Hussey 1853, pp. 113–17.

12 Jones and Monroe 1955, p. 27.

13 Getatchew Haile 1979, p. 318.

14 Budge 1928 [reprint 1976], pp. 1164–65. However, Abba Sälama could be a bishop of a different period; see, for example, Conti Rossini in *Aethiops*, no. 1 (1922), pp. 2–4, and 1, no. 2 (1922), pp. 17–18.

15 See Constantius's letter preserved in Athanasius's *Apologia ad Constantium* in Szymusiak 1958, pp. 125–26.

16 The classic study on this subject is Trimingham 1952.

17 Lings 1983, p. 80.

18 Lings 1983, p. 81.

19 Lings 1983, p. 81.

20 Trimingham 1952, p. 86.

21 Basset 1897; Whiteway 1902.

22 For details, see Tzadua and Straus 1968, pp. 93–97.

23 Getatchew Haile 1992, p. 143. See also Conti Rossini 1910, pp. 581–621; Heldman in Rubenson 1984, pp. 131–42.

24 Daoud and Hazen 1959, pp. 65–66.

25 Daoud and Hazen 1959, pp. 65–66.

26 Ullendorff 1968.

27 Wendt in *Journal of Semitic Studies* 9, pp. 107–13.

28 See Conti Rossini 1941, pp. 129–45.

29 Leslau 1983, pp. 61–82.

30 Conti Rossini and Ricci 1964, pp. 22–25, 1965 translation, pp. 13–15; Getatchew Haile 1991.

31 For the two positions, see Polotsky in *Journal of Semitic Studies* 9, pp. 114–21; Rodinson in *Journal of Semitic Studies* 9, pp. 11–19.

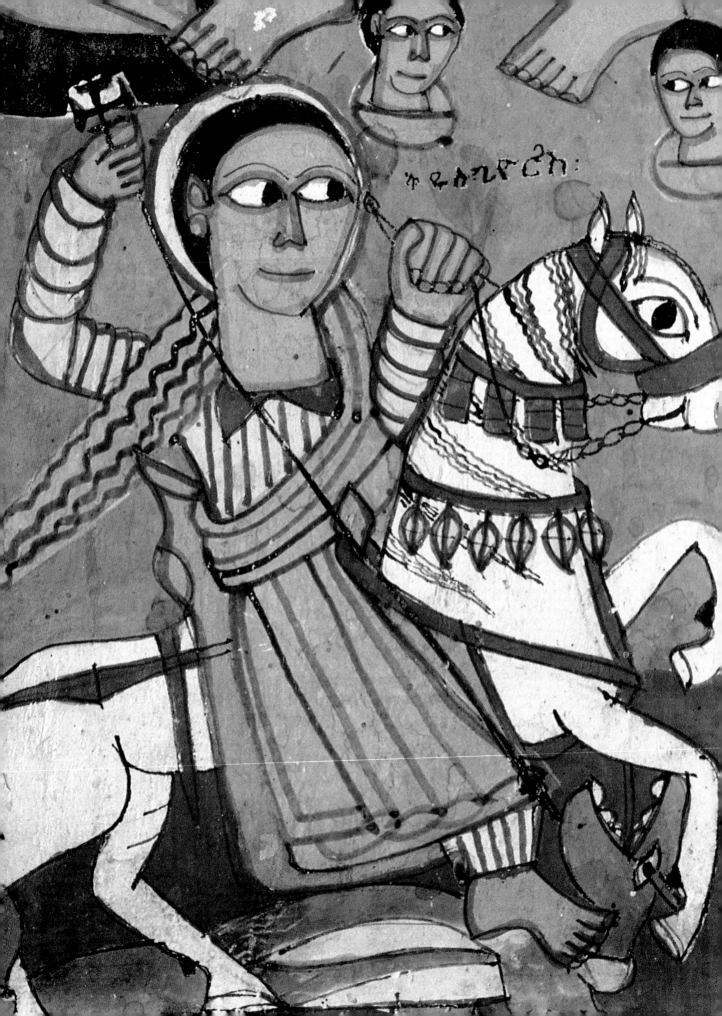

Ethiopian Art History

JACQUES MERCIER

CNRS, Ethnology and Comparative Sociology Laboratory, University of Paris-X

Men of letters in Ethiopia are commonly said to have two faces, one turned towards the light (which is the Christian faith and spiritual life) and the other towards the shadows (which represent the practices of magic and healing that are dignified with the collective name of wisdom). The same may be said of Ethiopian art. The introduction of magical or talismanic art from the Hellenistic cultures of the eastern Mediterranean probably dates from the fourth century, the same period that saw Christianity spread throughout the country. If one were dealing with the art of the modern era, the term "Ethiopian" would apply to a much broader field and would encompass art linked to other monotheistic systems and other religions. In earlier times, however, Ethiopian identity was so integrally linked to Christianity that "Ethiopian art" can be understood to mean the art of the Christian kingdom governed by the ruler known as the Negus.

While the craft of writing was for the most part considered a minor art in the West, this talismanic art enjoyed a different status in the civilizations of the East. For the disciples of Plato or Pythagoras, and later for the alchemists and kabbalists, the letters of the alphabet were endowed with a significance that was integrally linked to the creation of the universe. The art of writing in its most erudite form was a powerful and creative art. But while the physical or plastic expression of this thinking did not progress in the West and in the eastern Mediterranean, it underwent a prodigious development in Ethiopia, evolving in the course of certain hybridizations into an art form.

These figures, with both talismanic and Christian aspects, usually combined with texts on scrolls, had therapeutic as well as devotional powers. Unlike other Orthodox communities, Ethiopian Christians did not use icons in their homes for their devotions, although these were commissioned for parish churches; instead, they employed scrolls to safeguard the body as well as the soul. A priest would be summoned to the home to bless the inhabitants and read these scrolls.

Alongside this healing tradition, Christian art experienced three periods of expansion and triumph: during the Aksumite period, from the fourth to the mid-seventh century, then from 1400 to 1500, and, finally, between 1660 and 1760. Its monuments suffered terrible damage during times of political and religious upheaval around the tenth century and again in the sixteenth century.

When the West became aware of Ethiopian art at the end of the nineteenth century,[1] it was essentially through the illuminated manuscripts from the royal library, many of which were painted during the previous century in a style that appealed to European tastes. The destruction ordered by the Muslim leader Imam Ahmad in the sixteenth century offered little hope of retrieving any earlier works, until a series of finds over the past fifty years revealed the art of the fifteenth century. Today, this century is considered a Golden Age of Ethiopian civilization. However, although the art of Ethiopia may now be better documented than that of other parts of the Christian East, our knowledge of it is still in its infancy.

Opposite: detail from cat. 23

The Aksumite and Post-Aksumite Periods (Fourth to Eleventh Centuries)

The very first archaeological evidence of the conversion of Aksum to Christianity is provided by coins. King Ezana, having minted coins showing a disk and a crescent, symbols of the local polytheistic religion, subsequently issued a coinage stamped with a cross. This change occurred between 325–50, that is, at the time of the evangelical activities of Fre Menat'os (Frumentius), the first metropolitan, or bishop, of the Ethiopian Church.[2] The spread of Christianity also affected other aspects of Ethiopian society, including royal funerary rituals. Stelae, large stone pillars, were no longer erected over tombs, although these continued to be places of pilgrimage. Christian funerary chapels superseded the edifices of the indigenous religions. This adaptation has been characterized as a meeting of the Aksumite funerary tradition with the mode of worship centered on the tombs of martyrs and pilgrimage sites.[3] These new Christian traditions were at the root of a major phenomenon in Ethiopian Christian architecture, namely monolithism. Pilasters, capitals, lanterns, and the frames of false windows carved from the rock imitate Aksumite architecture, while the basilica form, as hewn at places like Degum, Baraqit, and Hawzén, became progressively more common.

Some churches built of wood and stone have survived. The oldest is on the western edge of the Tegray plateau at Zaréma.[4] Square-shaped with short lateral aisles, its structure does not appear to have been substantially altered since its construction in the eighth–ninth centuries. The walls are constructed in the Aksumite style using beams and dry-stone walling. The heightened

central nave is decorated with false windows. The plant motifs carved on the ceilings, the openings of the false windows, and the capitals and the corbels, all characteristic of pre-Islamic Egyptian decorative art, attest to the antiquity of this church, which is dedicated to Saint George. The most famous church of this type is at Däbrä Damo, located on a mountaintop and accessible only by a rope, which, tradition has it, was braided in imitation of the patterns on the skin of the python that hauled ZäMikaél, the founder of the monastery, up the cliff. Däbrä Damo, the "mother" of Ethiopian monasteries, was a beacon of learning and, thereby, a driving force throughout the first millennium of Ethiopian Christianity. The building, which displays a number of older features, such as a superb ceiling carved with animal designs, seems, however, to have been rebuilt or remodeled several times. Another, and perhaps the finest of these churches, is located near Zaréma, at Däbrä Sälam.[5] Situated in a cave on a cliff-face, it is partially built and partially hewn out of the rock. The central nave of the basilica ends in a finely carved chancel, as at Zaréma, but is distinguished by its superb paintings, possibly the oldest murals surviving in Ethiopia (fig. 14). There is no image of the Crucifixion, the scenes of the life of Christ depicted— the Entry into Jerusalem and Christ in Majesty—being solely triumphal.

Up to the present, it had been believed that all Aksumite liturgical objects that would have been used in such churches were lost. The compilation of a new inventory of movable treasures from various churches, however, has revealed a large number of previously unknown objects as well as their place of origin.[6] This process has allowed certain metal items to be dated

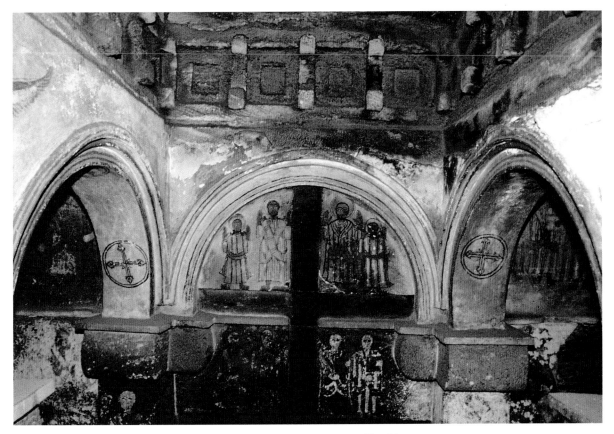

Fig. 14

Interior view of the nave, Church of Däbrä Sälam, Tegray (11th–12th centuries)

The painted scenes of the life of Christ in the church of Däbrä Sälam are perhaps the oldest in Ethiopia. The church itself is carved out of rock, with false windows (above the arches) that imitate Aksum architecture

earlier than hitherto assigned. In particular, this was the case for the iron crosses *(beträ mäsqäl)* that monks used as walking sticks and which they planted in the ground while they prayed or preached. Their shape echoes the knots on the bamboo crosses of the Desert Fathers of the early Christian period. One example of this sort of cross is represented in the tenth century frescoes at Faras in Nubia (Sudan). The oldest of these may date back to the eighth century, but certain forms continued to be produced until the fifteenth century.

The dates of manuscripts from the period have also undergone a reassessment after recent examination. For example, two Gospel books originally assigned to the eleventh or twelfth century and preserved at the monastery of Abba Gärima in Tegray are much older than was first thought. Eusebius's prologue and the canon tables are framed by painted arches, whose prototype dates back to late antiquity. Recent carbon-14 dating of one of the books has shown it to be five centuries older.[7] Even allowing for the drawbacks of this dating method, many stylistic and iconographic elements indicate an earlier date, particularly the miniature of the temple at the end of the canon tables.

Where were these paintings that are so astonishingly close to Coptic work, but also to that of Syria and Armenia, actually produced? Before the rise of Islam, Ethiopia was a rich country, minting coins and controlling the Red Sea trade. Traders or Ethiopian monks could have brought these illustrated manuscripts from Jerusalem, but it is certainly possible that, in order to disseminate Christianity, the Aksumite king could have founded workshops where Middle Eastern artists or their Ethiopian students may have copied and illustrated texts.

The Zagwe Dynasty (Twelfth to Thirteenth Centuries)

After several centuries of war and destruction, and as the Red Sea fell to Muslim control, political power shifted southward to the mountains of Lasta. This move was connected to the rise of the Zagwe dynasty during the eleventh and twelfth centuries. Around 1200, King Lalibala, the most illustrious of its rulers, had ten magnificent churches carved out of the volcanic tuff. These were the first truly monolithic churches as they stood completely free from the rock and, when seen from the outside, formed perfect imitations of built structures.[8] The treasuries of these churches contain a dozen crosses of a very unusual type, which are known as Lalibala crosses as they were first found here. The cross is set under a graceful arc that echoes antique triumphal arches. Sometimes, this cross, which might be a double or even a triple cross, is circumscribed by a two- or three-lobed mandorla (an almond-shaped halo) to which are attached two or three pairs of wings (fig. 15). The wings basically refer to the vision of Ezekiel and are associated with the Four Beasts carrying the throne of God. The sanctuaries of Lalibala's churches also conceal a number of portable wooden altars, not found anywhere else in such abundance whose original function remains obscure. Decorated with palmettes like those seen on the crosses and the church windows, the altars are inscribed with King Lalibala's dedications to Mary, to the angels, and to others.

Fig. 15

Processional cross, 54.2889, Walters Art Museum (cat. 1)

This processional cross, of the Lalibala type, has a small, central cross set within a mandorla that normally surrounds the figure of Christ

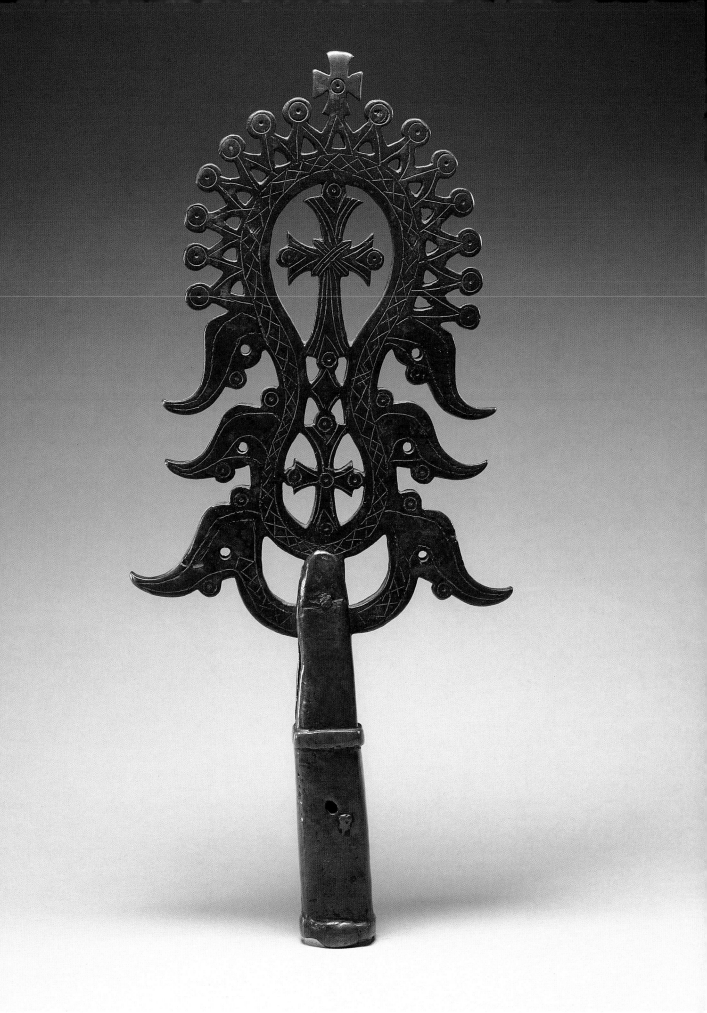

The Era of Amdä Seyon (1270–1382)

Mired in disputes over succession, the Zagwe dynasty was overthrown by the chief of the Angot, Yekunno Amlak, who set about supplanting its memory by constructing new churches, of which two rock-hewn examples have survived. The walls of the larger one, dedicated to the monk Mät'a'e, are decorated with paintings of more than a hundred subjects, including a dedicatory portrait of the king. The fourteenth century was dominated by the figure of King Amdä Seyon (reigned 1314–44), who considerably extended the boundaries of his realm and thereby assured relative security for subsequent generations. His conquests gave rise to increased evangelical activity among the monks, with whom he had a fluctuating relationship.

Characteristic of this period, judging from the documents that have survived, is the production of Gospel books containing, after the canon tables and the temple image, three scenes of Christ's Passion: the Crucifixion, the Holy Women at the Tomb, and the Ascension. Ten more or less complete Gospels of this type, dating from the beginning of the fourteenth century to the early fifteenth, have survived, including one at the Walters (cat. 10). The three figural images all derive from Palestinian prototypes of the fifth to sixth centuries.[9] They represent the holy sites of Jerusalem, such as Golgotha, where the Byzantine emperor erected a jeweled cross in the ground,[10] and the Holy Sepulchre, containing the tomb visited by the Holy Women. The appearance of these monuments was known from various sources, among them pilgrims' flasks. The symmetry of the manuscript scenes, which is unique in the case of the Holy Women, suggests that these images may be copies of the monumental compositions on the apses of the Church of the Holy Sepulchre in Jerusalem. The cross is surmounted by a lamb, the symbol of Christ, following a tradition that was banned in Byzantium at the end of the seventh century. In certain Ethiopian paintings, the sun and the moon are represented in the guise of bust-length figures following antique tradition. The Four Beasts bearing the mandorla of Christ in the image of the Ascension are placed in different positions in various manuscripts, which helps date their creation to before the ninth century. After this period, these positions became fixed.

These three images are the most characteristic examples of the conservatism of the Ethiopian Church. One constantly finds in its art as well as in its liturgy traces of the traditions of early Christianity (including those of Palestine) prior to the fixing of artistic and liturgical canons.[11] This conservatism owes much to the isolation of Ethiopia as a result of the emergence of Islam in the surrounding regions.

The narrative cycle of the life of Christ, including the three images discussed above, was at times extended to include up to fifteen different scenes. In the Gospel book commissioned by the abbot Iyäsus Mo'a of Hayq, illustrated in 1280, a depiction of the Crucifixion (without the crucified Christ) appears next to an image of the Arrest of Christ, the prototype of which presumably dates back to the seventh or eighth century. Also included is a Nativity of much later inspiration, even though the faces, still elongated and bobbin-shaped, retain elements of earlier Coptic art. This extended pictorial cycle became increasingly popular. Over several decades, Arab-Islamic style and Byzantine iconography were increasingly assimilated into Ethiopian art. Typical of the former is the fragmented arrangement of elements in the composition.

The best examples of this blending of styles were produced in the early fifteenth century.

Although the authority of the monasteries had been transferred to the region of Amhara, Tegray remained a focal point for monastic life and learning. Religious fervor led monks once again to carve churches out of the rock, notably in Gär'alta. Studded with red sandstone cliffs, this region has some of the most beautiful landscapes in Ethiopia. While older rock churches were located on the plains, the monks of the late thirteenth century, prompted by their desire for contemplative isolation, carved edifices on top of the cliffs. Concerns about threats from the outside world may also have played their part. The oldest and largest of these mountain churches is at Qorqor, at the summit of the mountain.

The bronze crosses from these churches, as far as one can tell given the difficulties of dating their forms, conform to earlier types. Among these designs, a particularly successful variation on the Lalibala cross (a cross placed under an arch) is exemplified by a processional cross preserved in Gär'alta. Examples of another style developed at Lalibala, the trifoliate cross, have been found in the monasteries founded by the great saint Ewosṭatewos (1273–1352).

In all, this period gives the impression of a phase of revitalization. New prosperity led to an artistic boom and an openness that provided a springboard for regeneration.

The Era of Dawit (1382–1478)

A translation of the Arabic book the *Miracles of Mary* was commissioned by King Dawit (reigned 1382–1413) for his personal use and is the oldest surviving illustrated book to be ordered by a king. The preparation of the ink for this group of texts was believed to be the occasion for another miracle, as Mary intervened to give a particular brilliance to the gold paint, which had been prepared by a foreign artisan and would be used to write her name and paint her robes. Today this book is kept on Mount Geshän (fig. 16). Ten of its twelve images show Dawit at the feet of the Virgin and Child, flanked in the local style by the archangels Michael and Gabriel. They are painted in a manner that remained fashionable up to the time of Zär'a Ya'eqob, the last of Dawit's sons to accede to the throne (reigned 1434–68). Also in this style is the famous collection of sacred texts known as the *T'éfut*—because, it is said, the writing is as tiny as teff, the fine-grained cereal that constitutes the daily staple of the Ethiopian diet. When Zär'a Ya'eqob, who venerated Mary, wished to promote the cult of his patron saint, he had his propagandists distribute collections of the *Miracles of Mary*, illustrated in the *T'éfut* style.[12]

This royal art ran parallel with another style that, although differing from it, sprang from the same root. Both are characterized by a geometrical quality, enlarged hands and eyes, and an absence of scenery, as well as the intricate relation of the bands and the patterned planes in the clothing. But while in the royal style bands around the hems of the clothes (or indicating the shape of the body) are almost always functional, in the other style, there are sometimes so many bands that they appear to be bandages binding the body. Alternatively, these bands are simplified to the point where they outline a silhouette that is filled with geometric lines, which gives a formal quality to the figures. This geometric style, which appears in a *Book of Hours* painted for Samuel of Waldebba,[13] the most

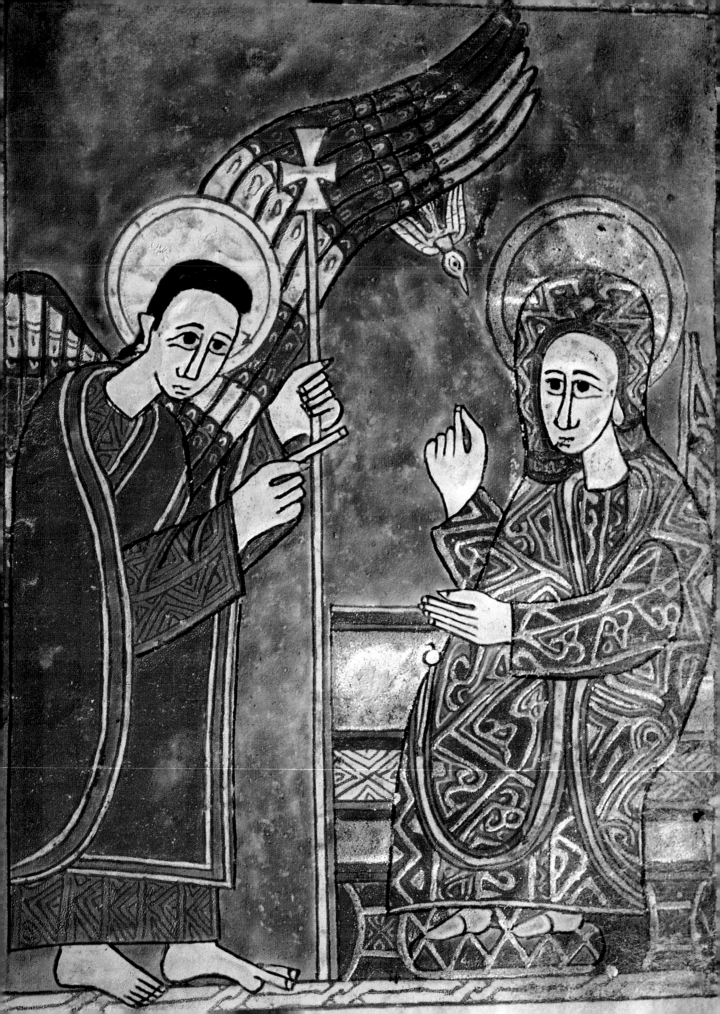

popular saint of this period, will be referred to as the Samuelite style, in the absence of an artist's name.

The royal style was used mainly to decorate Gospel books or Marian literature, while the Samuelite style is commonly found in the decorations of prayer books and ascetic literature, as well as in the principal book of Ethiopian worship, the Psalter. This same Samuelite style lends great dignity to the thirty-six figures of a magnificent folded panel painting, mounted in a fan-shape and executed around 1420 for a church in Gär'alta.[14] Since many of these manuscripts have been taken out of Ethiopia, their origins are unknown, but it seems that the royal style was more common to the Amhara region, and the Samuelite style prevailed in Tegray. The Ethiopian antecedents common to these styles have not been found.

Aside from the *Miracles of Mary*, the name of King Dawit is also associated with one of the most beautiful illustrated books of the period, the Gospel of the Monastery of Saint Gabriel on the isle of Kebran in Lake Tana. The eighteen illustrations of its extended cycle include more examples of Byzantine iconography than before, notably in the depiction of the Annunciation, the Crucifixion, and the Resurrection.[15] All the scenes are placed beneath three-lobed arches with mosaic decorations in an Islamic style.[16] The Walters Art Museum has two images taken from an extended cycle, which is now dispersed (see cat. 11). Their blue backgrounds perpetuate a fashion that was popular in Byzantium from the sixth to the tenth centuries. It was also during the age of Dawit that it became common, having been a rarity before, to paint interlace bands above the text of manuscripts.

The surviving mural paintings in this style are confined to the rock churches of Tegray. Däbrä Seyon, which was carved at the end of the reign of Dawit and generously endowed by his son Yeshaq (reigned 1414–28), is the most remarkable example: the walls, ceilings, and pillars of the basilica are painted mainly in shades of green and white. Some images, added shortly afterwards, recount episodes from the life of the church's founder, Abreham, whose masterpiece and final work it was.

Also in this period, at the request of an ambassador from King Dawit, the Republic of Venice sent, among other artisans, a painter who worked in Venice but was originally from Florence. Soon after, it was the turn of Yeshaq successfully to petition Alfonso V of Aragon to send other artists. One of these painters brought with him certain elements of western iconography, as well as the technique of using tempera on gesso-covered wood panel. An artist of only modest abilities, this painter founded a studio that attracted talented students, among whom was a certain Fre Seyon, who quickly established himself as one of the greatest Ethiopian painters.[17] The church of Saint Stephen of Daga holds a large portrait of the Virgin Mary signed by the artist, which has unfortunately been disfigured by recent repainting. Fre Seyon's style of depicting clothing brings together flat geometric patterns and regular lines suggesting pleats, while the base of the robes are hemmed with ripples. Eastern influence is discernible in his art, which successfully unites various currents. An image of Mary on loan at the Walters may be attributable to him (cat. 20). Both of these large portraits are the direct expression of the liturgy imposed by Zär'a Ya'eqob, who insisted on the presence of a portrait of Mary during Mass. During his reign, the production of paintings on wood panels, until then sporadic, increased dramatically. Dozens of

Fig. 16

The Annunciation, from the *Miracles of Mary*, Ethiopia, early 15th century, tempera, ink, and gold on parchment, Church of Geshän

This early manuscript of the *Miracles of Mary* was commissioned by Emperor Dawit (reigned 1382–1413). It is rare and precious for the use of real gold on the pages

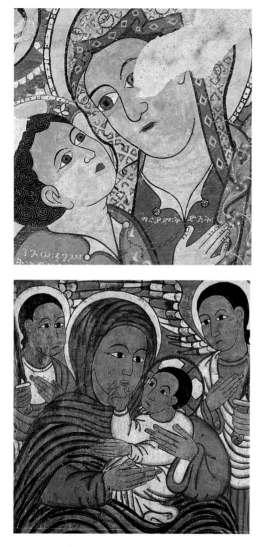

Figs. 17 and 18

Top: By Fre Seyon (detail of cat. 20)

Bottom: Attributed to a follower of Fre Seyon (detail of cat. 21)

The great influence of Fre Seyon is reflected in the number of icons attributed to the artist himself (top) or to one of his followers (bottom)

paintings from a school that one could call the school of Fre Seyon have been discovered, among them a diptych at the Walters (cat. 21).

Ethiopians have never felt the need to theorize about the image, doubtless because they never encountered the destruction of paintings through iconoclasm. Instead, any mention of them in written sources is more likely to detail how they have played an active role in the lives of Christian Ethiopians. *The Lives of the Saints*, written in the fifteenth century, mentions miraculously speaking paintings. This text, which is adapted from the accounts of the *Miracles of Mary*, shows that, just as in the West, Ethiopians believed in miraculous icons. One miracle of Mary written in the time of Zär'a Ya'eqob describes how an image came to life:

> This icon is clothed with a (human) body. It moves and talks. The Spirit of God dwells in it. You should not think that it is a mere picture. She is, indeed, Our Lady the Virgin (herself) and he is Jesus, the only begotten Son (himself). Michael and Gabriel too are as themselves, as that icon [has spoken] to a certain monk.[18]

Images are also found on the altar tablet, known as a *tabot*, which was consecrated by the bishop. If it were ever removed from the building, the church would lose its sacred status. The priests hid it from the sight of the laity to the point where its decoration was unknown to them. It seems that altar tablets were occasionally painted. The only known example, delicately carved on the exterior, opens into a diptych whose panels show respectively a portrait of Mary and one of the Ancient of Days surrounded by the Four Beasts (fig. 19).[19] The style of the images is Samuelite and is the work of a manuscript

illuminator. The surface coat is thick and crackled and the scenes are painted directly onto unprepared wood. Icons crafted in this manner may have been produced in response to the liturgical directives of Zär'a Ya'eqob, but they could also derive from the tradition of painted altars, whether in the shape of tablets or thrones, a tradition that is certainly older.

Another essential liturgical object was the cross. The importance of this symbol was increasingly emphasized by the inclusion of multiple crosses within a single, larger cross. Thus on many processional crosses, the openwork circle bristles with little crosses on its edge, while its interior decoration is comprised of concentric circles linked by small crosses converging on the central cross, which is itself of a small size (see cat. 4). The interlace patterns, first used in manuscripts, were also adapted to the art of the cross, where they were interpreted as foliage from the tree of life or as the brazen serpent from the rod of Moses. Similar interlace also decorates the interior space of the crosses whose Greek form was a new development: the Ethiopians call these *wänfit* ("sieve") crosses because of their tracery decoration. Their promoter was a daughter of King Dawit, who donated such crosses to various churches.

Another characteristic of the period was the spread of figurative engraving on broad-armed crosses, with scenes including the Crucifixion, the Virgin and Child, God the Father (the Ancient of Days), angels, and saints (for a later example, see cat. 6). The finest examples were presented by King Yeshaq in the Tegray region and by Zär'a Ya'eqob to Däbrä Nägwädgwad, a church he founded. Bronze seems to have predominated as a medium for processional crosses. Benediction or processional crosses, which now

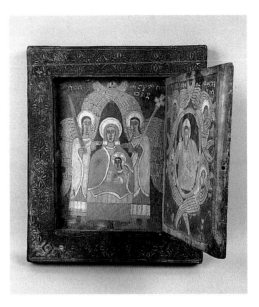

Fig. 19

Our Lady Mary with Her Beloved Son, the Ancient of Days with Evangelist Symbols, altar tablet in the form of a diptych, Ethiopia (Shoa), 1420–50, tempera on wood, closed: 16 ¹⁵⁄₁₆ x 14 ⅜ in (43 x 36.5 cm), private collection

When closed, the office of the mass is celebrated upon this two-panel altar tablet, or *tabot*. The panels are painted in the style of 15th-century manuscripts and not in the more Italianate style of the icons

appear to be a dull black iron, make it difficult to imagine how splendid fifteenth-century crosses, originally plated with gold or silver leaf, once were.

Inventories of church treasuries list other important liturgical objects such as patens and chalices made of gold or silver. None of these survive, except for the extraordinary gilded silver chalice of Abba Gärima, on which are carved the portraits of fifteen prophets and twelve apostles in the Samuelite style.

The Era of Opposites: Stephanite and Venetian Art (1480–1530)

Around 1480, a monk named Ezra returned from Egypt and Jerusalem, where he had been forced to go to be ordained as his order had been excommunicated in Ethiopia. He was a second generation disciple of Est'ifanos, a monk who had given himself over entirely to God and was martyred by Zär'a Ya'eqob for refusing to recognize, let alone honor, royal authority. His death gave rise to legions of martyrs and armies of disciples, and their excommunication had only served to fuel the movement.[20] While in Egypt, Ezra also took the opportunity to complete his training as a craftsman. On his return to his monastery at Käswa, he took advantage of the relaxation in persecution to develop skills—such as the carving of wooden crosses—while his brothers copied and illustrated sacred books. Summoned to court some time later by King Naod (reigned 1494–1508) for his technical skills, he managed to have the excommunication of his order revoked. The Stephanites, who had been accused of failing to venerate the cross and Mary, soon established themselves as the foremost carvers of crosses and greatest

illuminators of manuscripts in the country. They tended to choose ebony for their carving and employed the technique of marquetry (fig. 20).[21] Their painting style, which was essentially native to their region, brought the royal style to its pinnacle. The formal elements, such as the depiction of drapery, inanimate objects, and the figures themselves, underwent changes to the point where one could characterize this new art as geometric mannerism.[22]

Immediately following Ezra, an artist monk from Venice named Nicolò Brancaleon arrived in Ethiopia and quickly cut a swathe through the court of King Eskender (reigned 1478–94).[23] Brancaleon practiced the international Gothic style like his predecessors from the West, and was entrusted with icon painting, the illustration of books, and the decoration of churches. His pre-eminence remained unchallenged for more than forty years, during which time he founded a studio and created new iconographic elements for the Ethiopians, who were up to this point very tentative in this respect. Brancaleon's images of the martyrdom of Saint George and of the miracles of the Virgin Mary remained fashionable until the eighteenth century.

The development of the schools of Ezra and Brancaleon, one in the Tegray region, the other in the royal court, does not seem to have supplanted the school of Fre Seyon. During the early sixteenth century, King Naod commissioned an artist of this school to decorate a church he had built in the Jämmadu cave in Lasta. In fact, the taste for figurative art seemed to grow, as is apparent in its new use on crosses (see cat. 5).

The actual casting of crosses from the Zagwe period to the mid-fifteenth century also altered as well. The thickness of the copper alloy used was reduced from 8 mm to 4 mm and became thinner still towards 1500. Brass leaves of 2

to 3 mm thickness were cut out in the shape of a quadrate cross with short arms surrounded by volutes, or curves. The cross shape, which is almost square, offered a blank canvas for engravers.

While the monastic workshops continued along the path of covering pages of manuscripts with ever-wider bands, the art of interlace was rejuvenated at the court with the adoption of more refined Islamic motifs, simplified forms of which ornamented crosses.

Muslim and Jesuit Turmoil (1530–1632)

The chronicler of the conquest of Ethiopia by the troops of Imam Ahmad of Harar gives the following account:

> "Open the door so that we may come in," the soldiers said to the imam [who had gone into the church of Mäkanä Selassie]. He opened it, they rushed in. . . . They set to work with thousands of axes ripping up the gold and gems which were in the church, from the middle of the afternoon to the evening: Each took as much gold as they wanted and enriched themselves forever; more than a third of its gold was burned in the church.[24]

Everything that was not pillaged was burned. In order to destroy the murals in the rock churches, the soldiers lit fires in them. The only places that were spared by the imam were a few sites in Lasta and in Tegray. Imam Ahmad ranks with Gudit, who destroyed Aksum, as one of the worst scourges of Ethiopia.

Once the Muslims had been beaten back with the help of the Portuguese, the first task of the new rulers was to reconvert a large part of the population to Christianity,

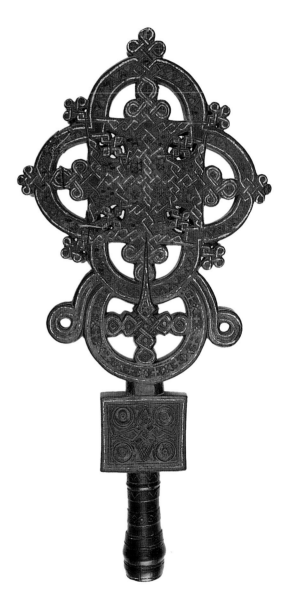

Fig. 20

Hand cross, Ethiopia (Tegray), ca.1500, ebony with marquetry and silver wire, 18⅜ x 8⅝ in (46.5 x 21.7 cm), private collection

This hand cross is thought to have been made by the monk Ezra, around 1500

and to rebuild the churches and fill them with the required texts. This left few resources for the painted embellishment of these books, whose use was largely ceremonial. Due to their liturgical function, the production of icons, on the other hand, flourished.

Throughout the century following the liberation of Ethiopia from Muslim control, the evolution of painting consisted of a slow fusion of various pictorial styles, primarily the blend of the geometric style of the monastic tradition with different figural influences from the West. No book with any substantive illustrated component has survived from the early 1600s, or may even have been created. The taste for these decorated volumes seems to have been in decline. On the other hand, small icons abound. Their production seems to have been confined to Amhara, and, consequently, often shows the influence of Nicolò Brancaleon. Few fragments of monumental painting have been found, such as the paintings on canvas commissioned by the emperor Särs'ä Dengel for the church on the island of Daga in Lake Tana.[25] The constrained style of these works demonstrates the lack of resources and outside influences during this period. Artists then reverted to older decorative conventions, such as the use of ornamental metal plaques on book covers. As a result of Muslim pillaging in Ethiopia, objects, like crosses, that had previously been molded in bronze or precious metals were now copied in the less costly medium of iron. The production of large stick-like crosses soon gave way to that of small hand-held ones. But very few crosses made between 1530 and 1650 have survived, partly a result of limited production.

The arrival of the Jesuits in the 1550s, in the wake of the Portuguese troops, did not at first fulfill the hopes of Ignatius Loyola, but were later realized at the turn of the century when two successive kings were converted to Catholicism. They impressed the court with their skills in architecture, building a royal residence at Dänqäz as well as churches, one of the most notable examples of which is the rebuilt church of Märt'ulä Maryam. Originally constructed by King Bä'edä Maryam and Queen Eléni during the 1460s, it was successively destroyed by the Muslims and the Oromo. On his conversion to Catholicism, King Susenyos had it rebuilt by the Jesuits.[26]

The Jesuits' influence on painting was limited to the introduction of a few iconographic variations in the pose of the Virgin, the main one derived from the Virgin of Santa Maria Maggiore,[27] which was disseminated throughout the world at the initiative of the Jesuit third general Borgia. An austere image, it shows the infant Jesus seated on Mary's left arm, holding a book and making a gesture of benediction. This painting, which pays homage both to Mary as mother of God and to Christ in his evangelical activity, became extraordinarily popular and supplanted all other representations of the Virgin and Child (fig. 21).

The influence of the Jesuits ended in 1632 with the abdication of the Catholic King Susenyos at the onset of a bloody civil war. Orthodoxy was swiftly re-established by his son Fasilädäs (reigned 1632–67), and led to the expulsion of the Jesuits and the closing of Ethiopia to westerners for almost two centuries.

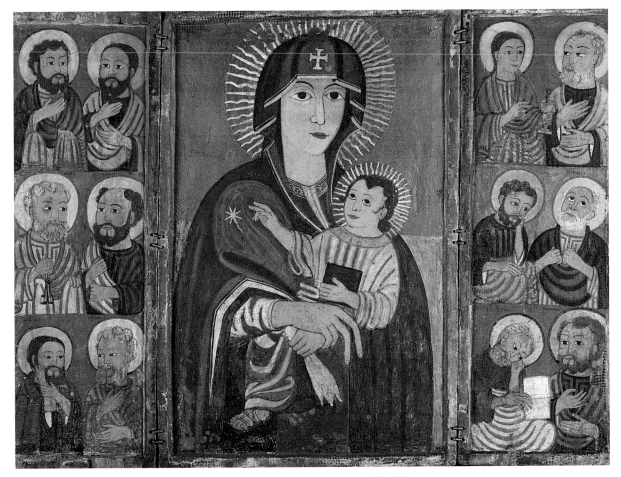

Fig. 21

Our Lady Mary with Her Beloved Son and apostles, triptych icon, Ethiopia, early 17th century, tempera on cloth mounted on wood, 23⅝ x 32⁵⁄₁₆ (60 x 82 cm), private collection

This triptych represents one of the first known copies of the Santa Maria Maggiore icon popularized by the Jesuits. It predates the use of archangels to flank Mary and Her Son, a composition that later became almost standard in Ethiopia

Renaissance (1660–82)

King Fasilädäs, when not conducting military campaigns, divided his time between several fortified residences around Lake Tana, the most important of which was at Gondar. Having spent much of his life in conflict with the Orthodox clergy, he only turned to this religion towards the end of his life. He had several churches rebuilt from their ruins, such as the cathedral of Aksum, and built bridges to allow pilgrims access to the great monasteries. As a consequence of his turn to Orthodoxy, he commissioned profusely illustrated books that had as many as 200 paintings. This was unprecedented in Ethiopia, where no book had previously contained more than fifty illustrations. The two main texts are the Gospels and the *Miracles of Mary*, with iconographic references adapted from western sources.

To illustrate the *Miracles of Mary*, King Fasilädäs's illuminators turned for inspiration to the images produced in Ethiopia itself by the ubiquitous Nicolò Brancaleon.[28] In this endeavor, either the illustrators used only the edition of Brancaleon's work at Tädbabä Maryam and were compelled to invent several compositions, or they had access to another "Brancaleon" collection, now lost. For the Gospels, they used the "Arabic Gospels," printed in Rome in 1591, with illustrations by Antonio Tempesta.[29]

The palette of Ethiopian illuminated manuscripts is dominated by yellows and reds like the paintings of this period. The backgrounds in the illustrations in both the Gospels and the *Miracles of Mary* though are no longer colored, but white. This stems from the blank background of the block prints and from the very pale wash of Brancaleon's backgrounds, but also, more profoundly,

from a change in fashion. Patrons had become tired of pages overwhelmed with interlace patterns, opaque miniatures, and dense writing. They now preferred vast expanses of white surface. This period saw the appearance of widely spaced writing with lettering that was twice as tall as before, bordered by large margins of white, with figures identified by long inscriptions.

Colored grounds continued to be employed in painting on wood, which, except for this element, adhere to the same style as the manuscripts. This style, which gradually became more sophisticated, is characterized by a rendering of drapery folds with fluid parallel lines, by red highlights on pink faces (already found on earlier paintings of the 1600s), and by a predominance of warm tones. This style resulted from a combination of various artistic traditions dating back to the fifteenth century, and is known as the First Gondarine style. Used also to cover the walls of churches, the painting style acquired monumental proportions.

Thanks to royal patronage and the existence of a fixed capital, the Gondarine style spread throughout the country. But its stylistic contribution and the iconography conveyed through its works were very quickly modified by regional artists, who had different traditions. The painters of Lasta, in particular, used a palette in which cold tones balance the warm colors that dominate Gondarine art.

On the whole, in regions such as Lasta and Tegray, the art of the monasteries was so firmly entrenched that western influences made little impact. Isolation and poverty also played a part in the continuity of the older traditions. With the rebirth of interest in painting in the seventeenth century, original styles began to re-emerge. Lasta saw the development of a very geometric style,

known mainly from a Gospel book preserved in the British Library (Or. 516) and some folded paintings, while in Tegray, the Stephanites developed a rustic style with which they covered large canvases as well as the walls of churches.

At the same time, a new shape developed in the art of the cross. The arms are now short and widely flared, and their ends are sometimes slightly curled. Most common are hand-held versions, but, less frequently, one finds processional crosses. As always, these crosses are flat and their two faces are identical. They do not have engravings; at the very most they have only a dedication, as on the processional cross dedicated by King Yohannes at Däbrä Wifat.[30] The Ethiopians call these "rams horns" because of the flared and curled shape of the arms. Initially, these were mainly made of iron and wood. Silver, bronze, and brass were used later.

Stylistic Regeneration (1690–1730)

The painters of the eighteenth century abandoned a several-hundred-year-old art form, characterized by geometric patterns and contrasting colors, and turned to fluid forms, which aimed at a realist treatment with gradations of tone and color. Why did this concern for realism develop within one generation when it had not existed before?

In the absence of any travel journals or lives of the saints, our only source of information is the chronicles of the period. Yet these are largely silent on the subject of art and artists. Thus, clues have to be detected in the art itself in order to identify the factors behind these changes.

Since the vast majority of these works are neither dated nor signed, it is not easy to reconstruct the process of transformation. While it may not be unusual to find a declining style coexisting with innovative new styles, it is surprising to find them brought together in the same studio and even in the same manuscript or book. This was, however, not unusual in Ethiopia at this time. Therefore, the *Miracles of Mary* that was handed down to King Téwoflos (reigned 1708–11) brings together eighteen images painted in the purer style of the first Gondarine school, forty-three images created by two artists in an intermediate style (with plump faces and sometimes colored grounds), and four illustrations marking a stylistic divide.[31] The more painterly treatment of these four images brought with it variations in tone and shade effected by means of over-painting with a thin-bristled brush, which allowed the underlying color to show through in places.[32] This was a novelty at the time. The coexistence of styles, which is quite common, can be explained thus: The studio's master, having accepted a commission, would execute the first part of the work and leave the rest to his assistants. The same phenomenon is found in the West both in illuminated manuscripts of the Middle Ages and in the Old Master paintings of the Renaissance and Baroque periods. What is interesting is the novelty of the style employed by the assistants.

If such diversity could exist within the same studio, there must have been great diversity among the different studios. Unfortunately, almost none of the works now dispersed in museums and private collections gives any indication of provenance. The current program of cataloguing church treasuries, however, is revealing a pattern in the distribution of styles. The capital, Gondar, must certainly have held an important place in the production of paintings. The requirement that abbots of

the great monasteries present themselves regularly in the capital gave them the opportunity to accept commissions, to deliver books, or, conversely, to buy them. On the other hand, the feudal system, which lent itself to a sometimes disruptive regional autonomy, allowed for the perpetuation of local styles.

Stylistic regeneration began in the 1690s with the appearance in manuscripts of areas of colored ground linked by graduated colors, which then affected icon painting and put an end to the compartmentalization that had been employed for centuries. At the same time, and not necessarily connected, the red mask-like patches on the figures' faces were abandoned in favor of delicate modeling. Then, the rendering of clothing became more realistic and sumptuous. The drapery folds no longer followed convention, and rich brocades of Indo-Persian, Turkish, or western origin were depicted with precision.

This regeneration began during the time of Iyyasu (reigned 1682–1706), a ruler who was eager to welcome westerners, provided they were not missionaries. The French doctor Jacques Charles Poncet, summoned to treat the king in 1698, wrote of him: "This prince seemed to me to have a marvelous genius for the arts. . . . He came to see my books, he admired the manner of their printing and he was as delighted by the art of printing as of engraving." Besides Poncet and his Jesuit companion, no other westerners are known to have come to Ethiopia during this time, and no western works of art were imported. The country was not closed to everyone though, as eastern Christians, Greeks, Syrians, Armenians, and Egyptians came to trade, work as skilled artisans, or engage in other activities.

The use of graduated grounds characteristic of the regenerated style is also found in the Christian East, in particular in the illustrations by Yusuf al-Masawwir made between 1659 and 1667 for the chronicle compiled by Matthew Cigala at the request of the Patriarch Macarius of Antioch. No painter from eastern Christendom would have failed to introduce the iconography of the life of Christ from his native land, unless he only painted simple decorations. Would the importation of a few images have been enough to effect artistic changes? It is more likely that a range of foreign influences in the country laid the foundation for this regeneration. To judge from the large quantity of Indian or Persian cloth found in Ethiopia or depicted in miniatures, trade with India and Persia was lively at this time. The image of Saint George spearing the dragon in the *Acts of Saint George*, which King Iyyasu gave to the church at Kebran on Lake Tana around 1705, derives from an Indo-Persian model, which itself borrowed the shape of the dragon from Chinese art.

One cannot, however, exclude the possibility that this revival was inspired primarily by the work of Ethiopian painters. Could an Ethiopian painter-monk have gone to Egypt or Jerusalem to complete his training, like Ezra two centuries before? Another possibility, though less likely, is that a painter was inspired by the gradations in color used by a foreign painter working in Ethiopia in the early sixteenth century. But this seems implausible given court fashion.

The nobility at court played a determining role in the success of this style, which appealed to their taste due to the delicacy of the modeling of the figures, the rounded body forms, and the magnificence of textiles. An increase in the production of books and of small, refined icons supports this hypothesis. The basic form of these icons

consists of a double diptych (see cat. 26 and 27). This opened on both sides in the same way as the earlier painted altars, the external panels being carved in a similar fashion to the altars.[33] The most sophisticated examples are composed of up to ten moving panels.

Although the images represented now exhibited the neo-Gondarine style, there were few notable changes in iconography. These innovations took several years to become established, particularly in the monasteries located a long way from Gondar. Thus, a manuscript commissioned by the abbot of Qoyäs'a for his monastery during the reign of Bäkkaffa (reigned 1721–30) still displays red highlights and many examples of clothing in the First Gondarine style, while the neo-Gondarine style had already become the norm for royal commissions. Lasta distinguished itself again by producing an original style, which was fresher and more spontaneous. In the most far-flung regions, such as Wäfla and Shoa,[34] the painters continued to draw their main inspiration from older images.

Iconographic Regeneration (1706–20)

During the first half of the eighteenth century, the iconography of the life of Christ was completely transformed: not only were the Crucifixion, the Resurrection, and the Last Supper depicted differently, but new images were

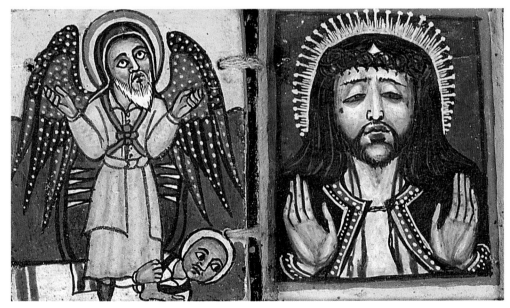

Fig. 22

Detail from cat. 27

created of events, such as the healing miracle at the pool of Bethesda (John 5:2), which had never before been illustrated. The complexity of the postures, the costumes, and certain decorations suggest that Ethiopian artists were largely inspired by foreign images. Recent research has shown that these painters used engravings from a collection published in France in the seventeenth century.[35] It was no accident that these works of art came to Ethiopia, and their history is, therefore, worth relating. The composition of the images dates back to the mid-sixteenth century, to a Jesuit project to illustrate commentaries on the Gospels. The 150 drawings commissioned from the Italian painter Agresti were successively redrawn by two artists before being engraved by the Wierix brothers. The first edition of their collection of 144 plates was printed at Antwerp in 1593. The work was a worldwide success. An edition was even presented by the Jesuits to King Susenyos in 1611, who had it colored but apparently not copied. This volume disappeared in the conflagration that followed the failure of the Jesuit mission. The Wierix brothers' plates were widely copied in Europe, notably in a Parisian edition of around 1650, in which 123 images were reproduced, with three additional plates. This collection was entitled *Synopsis of the Life and Passion of Our Savior Jesus Christ* and was continuously reissued until 1693. When the French doctor Poncet left Cairo for Ethiopia in 1698, he was accompanied by a Jesuit sent by the Order, which had not given up hope of re-establishing its position in the country. Aware of the success of the first edition with the King of Ethiopia, the Jesuit brought with him a copy of the *Synopsis*—this, at least, is the most likely scenario for the introduction of the engravings into Ethiopia. Exhausted by the trip from Cairo, the hapless Jesuit, who

was passing himself off as the doctor's servant, died less than a day's journey from Gondar. The volume reached the royal library, and after the death of King Iyyasu in 1706, Ethiopian painters began to draw ideas from it, at first cautiously but then more broadly. It is not known whether theologians expressed reservations about certain plates, but at least fifty of these compositions passed into the local repertoire. Thereafter, this iconography enjoyed considerable success and is still easily detectable in the painting of today.

Transition to Modernity (Eighteenth Century)

The great passion for painting in the first half of the eighteenth century brought about a revolution, namely, the creation of new iconographies by Ethiopian painters. They had moved from simply disseminating images to composing them themselves. In the final years of the seventeenth century, the *Lamentations of Mary* (a poem about the Flight into Egypt), the *Miracles of Jesus*, and, above all, the *Homiliary of the Archangel Michael* were illustrated for the first time. The Walters Art Museum has a particularly fine example of the *Homiliary of the Archangel Michael*, one of the two oldest known (fig. 23; cat. 15). The backgrounds are still white, the style very Gondarine, and the inscriptions numerous, as in the manuscripts of the *Miracles of Mary*. Then Iyyasu commissioned a copy of the *Acts of Saint George* in a transitional style. There followed a collection of biblical scenes composed in the manner of their European counterparts of the sixteenth and seventeenth centuries. The poem entitled *Wise of the Wise Men* provided the framework for this project. The finest of these manuscripts,[36]

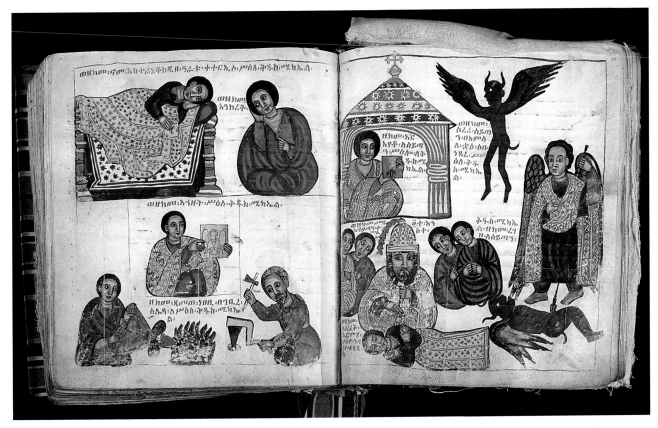

Fig. 23

The Story of Euphemia, *Homiliary and Miracles of the Archangel Michael*, W. 835, folios 72v–73, Walters Art Museum (*cat. 15*)

Starting at the top of the left-hand page (fol. 72v), Euphemia asks her dying husband, General Aristarchus, to commission an icon of Saint Michael to protect her after his death. At the center, Euphemia holds up the icon of Michael, and, at the bottom, craftsmen work on making the silver plaque that will cover the icon. At the top of the right-hand page (fol. 73), Satan, in the shape of a winged demon, visits Euphemia, and recoils when she holds up the icon of Michael. Michael spearing Satan is shown at the right. At the bottom, Euphemia prostrates herself at the feet of a bishop who has come to see her, drawn by her renowned holiness

which came from the royal library, includes 144 illustrated pages. Old and New Testament scenes are followed by previously undepicted images of the acts of the angels and of the church fathers, as well as of Ethiopian saints.

The most accomplished illustrations were created during the reign of Bäkkaffa (reigned 1721–30). Illustrated for him were an Apocalypse in dark tones, and, most importantly, a collection of the *Legends of Mary* depicting the flight of the Holy Family to Lebanon, to Egypt, and even on to Ethiopia.[37] In order to compose the book's 259 images, its painters must have made many innovations, putting together a grammar of forms that was far subtler than any previously used, and going so far as to incorporate into their repertoire elements as delicate as the tiny strokes that render shadows in western engraving. Carried away by all this enthusiasm, a patron named Wäldä Giyorgis went so far as to commission a commentary on the Bible in two volumes illustrated with almost 700 images by the painter Hézqel. This was left unfinished, like several other equally overly ambitious projects of the period.

During this same period, the neo-Gondarine style, also called the Second Gondarine style,[38] came to dominate all media, including wood panels, parchment, and murals, which had not been the case in the fifteenth century, when different styles were employed for different media. The monasteries, however, had previously been at the forefront of the development of art, while now this role fell to the nobility, which followed the lead of the king, and, in particular, the widow of King Bäkkaffa, Queen Mentewwab, who reigned as co-ruler until the 1760s. She was the patron who commissioned the construction and decoration of the church at Narga on Lake Tana,[39] as well as a lavish manuscript of Saint John's Gospel (fig. 24).

Earlier, the nobility had naturally played an important role, notably through a taste for western art, but the monasteries enjoyed greater autonomy and were trained in certain crafts. By the eighteenth century, painters were certainly still clerics, but they now worked for a nobility that seemed to enjoy a greater independence than in the past. The balance of power between the court and the regions, which made the system work, was fragile. If it was upset by centrifugal forces, war would break out in the country, which could bring with it destruction and impoverishment. This is what happened after the death of King Iyoas in 1768, which ushered in the Age of the Princes. There were no more rich patrons, and the nobility had to content itself with buying old books, when it was not simply seizing them during military campaigns. With the exception of mural painting, for which demand remained high, art went into decline.

In spite of the general poverty in the country, painters continued to extend the range of their subjects. In the mid-nineteenth century, they began to incorporate philosophical subjects showing the vanity of human existence, such as an adaptation of a story about the Buddha, called *Romance of Bäräläam and Yewasef*. In one instance, an image of King Bäräläam shows him complaisantly tasting the juice of the fruits of a tree and failing to notice that a black and a white rat—representing day and night—is gnawing the trunk, and that the serpent lurking at the base of the tree is preparing to swallow him.[40] Other highly prized subjects were Alexander the Great, the mortal who wished to visit Heaven, and Sirak, the wise man who seduced one of Solomon's wives.

Despite the difficult conditions of the time, artists continued to adapt styles and forms. For example, the late

Fig. 24

The Arrest of Christ, *Gospel of John*,
Ethiopia (Gondar), ca.1755, tempera and
ink on parchment, 13⅜ x 11¹³⁄₁₆ in (34 x 30
cm), collection of Sam Fogg, London

Christ wears a robe patterned with flowers
in the style of the nobility. To the right, a
demon perches on the head of Judas, and,
in the background, Peter attacks Malchus
(servant to the high priest) with a sword.
The composition is derived from two
engravings that were printed in France and
imported by the Jesuits

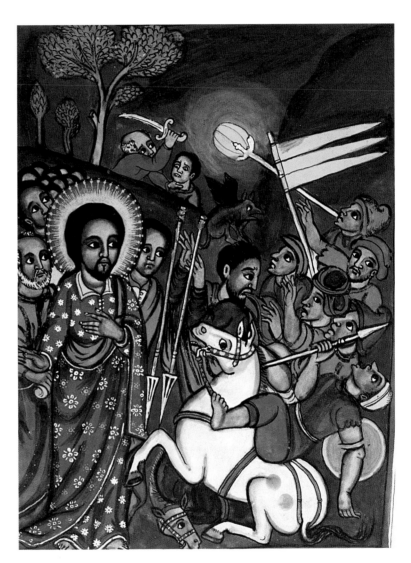

nineteenth century saw a revival of the art of interlace. In books, these patterns were now often embellished with vignettes showing sacred figures, or, more commonly, illustrating proverbs. Goldsmiths, while continuing to produce large Gondarine crosses decorated with engraved figures, revisited the shapes of the fifteenth century, particularly the Greek cross with internal interlace patterning (see cat. 4). They enhanced the centuries-old tradition by making them larger and adding to the complexity of the motifs at the extremities of the arms. At the same time, the long iron processional crosses came back into fashion; today's fluted iron crosses recall the ancient hammered imitations of the bamboo crosses of the Desert Fathers.

Secular Painting

Apart from religious art, very few secular scenes are known to have been illustrated in Ethiopia. At the beginning of the eighteenth century, the de-canonization of religious painting and, in particular, the illustration of the journeys of the Holy Family (and even the depiction of the exotic lands in the *Miracles of Saint George*) created the conditions for a new appreciation of secular painting. In the nineteenth century, it became customary to portray the military exploits of the commissioning patron as part of a church's decoration, usually on the east wall of the sanctuary. In the early twentieth century, this type of painting spread from the walls of the churches to the easels of artists who prospered in the new capital, Addis Ababa. Among the most popular subjects of paintings was the legend of the meeting of the Queen of Sheba and King Solomon, illustrated in many cases by a series of pictures, several dozen in all, rather like a cartoon strip.

Scroll Painting and Its Talismanic Sources

Knowledge of Christian art is of limited use in the interpretation of the art of healing scrolls. Certainly one can identify here and there an angel, a cross, or a man on horseback, but placing the complete and complex images within the general history of Ethiopian art is, for the most part, impossible. It would, therefore, be useful to set out some of the guiding principles of scroll production before attempting a historical perspective. These principles have been gleaned, in the absence of any written sources, from interviews with modern Ethiopian designers of talismans and by interpreting older scrolls.

First, the images in the scrolls are part of a more complex object, the scroll itself, which, in turn, is a part of a larger practice, the healing ritual. Whereas religious faith is exclusive, healing practice is basically inclusive: when the very survival of the body is at stake, unless one is a person of singular faith, there is no medicine that is not worth trying. In Ethiopia, just as in the modern West, the sick have access to a wide range of diagnoses and healing regimens. Scrolls, which have been used in Ethiopia for 2,000 years, have benefited during this period from various historical conceptions of healing. Consequently, their painted images have complex meanings of which modern-day makers and users are not always aware.

In many cases the preparation of a scroll is astrologically determined, a practice that has led the Christian Church to reject the use of scrolls. The concept underlying the scroll's creation is the theory of correspondences, which can be traced back to the ancient Greek origins of the scrolls. According to the theory, each human being has a

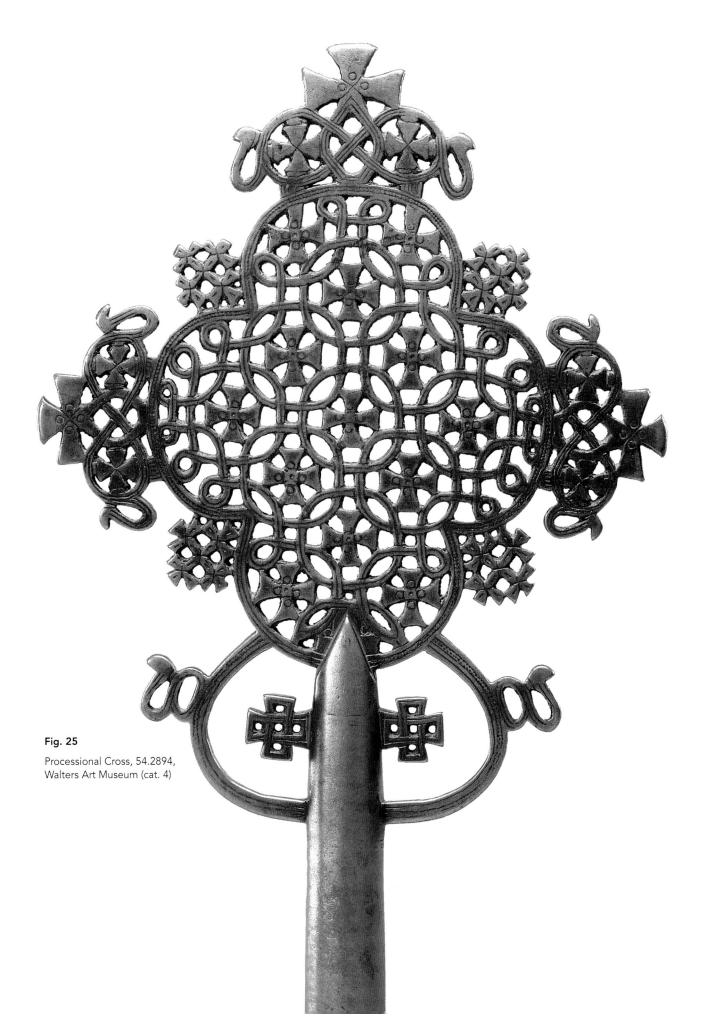

Fig. 25

Processional Cross, 54.2894,
Walters Art Museum (cat. 4)

corresponding sign of the zodiac, and thereby a particular destiny, illness, set of enemies, protectors, colors, prayers, as well as figures and talismans. In Greek treatises, each sign of the zodiac is associated with a talismanic character and a figure. The same is true in Ethiopia. This correspondence has been calculated, as far as is known, for the last two centuries by arithmomancy (divination by numbers) in the Islamic manner, that is to say, by associating numbers with the consonants composing the person's name and that of his or her mother.

The historical roots of Ethiopian talismanic writing lie in the script of the Hellenistic world, in modified Greek letters whose tails end in little circles. These are secret writings, believed to be powerful, and based on the idea that the world was created by the word. This concept, which is more than 2,000 years old, is still current among learned Ethiopians, who, consequently, continue to invent such secret alphabets. These pseudo-letters are associated with seals, whose model is the seal of God that was revealed to King Solomon. These letters, and sometimes these seals (properly called *mahtäm*), are known in the Ethiopian language as *t'älsäm*, a word that derives from the Arabic *t'ilasm*, which itself comes from the Greek *telesma*. The English word talisman was created at the end of the sixteenth century as a rendering of the Arabic or Persian expression.

Over time, the use of a codex or book as a material support for the written word has replaced the use of a scroll, which since antiquity had been the common writing surface. In the context of healing rituals, though, the use of scrolls has survived due to their direct relevance for the patient: the size of a scroll is equal to the length of the body of the sick person because it is intended to protect the person from head to toe. This aspect is enhanced by a sacrificial practice: the parchment of the scroll is prepared out of the skin of an animal—astrologically chosen—that has been sacrificed for the patient. Rubbing the ailing body with the still living animal, and later washing the body with the animal's blood, act to drive out the sickness together with the invading spirit that had caused it. The sacrificial animal acts as a substitute for the sick person, and thus the parchment scroll serves as a symbolic skin that regenerates the body's outer limits, which had been disrupted by the invading spirit. There is therefore a close relationship between the sick person and his or her healing scroll.

The oldest surviving Ethiopian scroll dates to the beginning of the sixteenth century. It comprises four seals, each a variation on the eight-pointed star, a motif that became common in Islamic talismans around the thirteenth or fourteenth century. Nonetheless, there is every reason to suppose that the use of scrolls dates back to ancient Aksum. Ethiopians in that period must have adapted certain foreign prayers, talismans, and protective motifs, the most remarkable of which is the Gorgon. On a scroll dating to the early nineteenth century (fig. 26), one finds the image of a Gorgon with staring eyes and snakes writhing on her head, holding two lions in the manner of Archaic Greek figures of the fifth century B.C. The Ethiopian image is too complex to be a chance invention. This figure often has been reinterpreted in the Ethiopian Christian context as a devil (Werzelya), a killer of children, or Satan, or, on the other hand, as a guardian angel, the archangel Michael, Christ, or a saint.

The Ethiopian Gorgon-like figures are even more fascinating than their Greek ancestors. This figure is not a

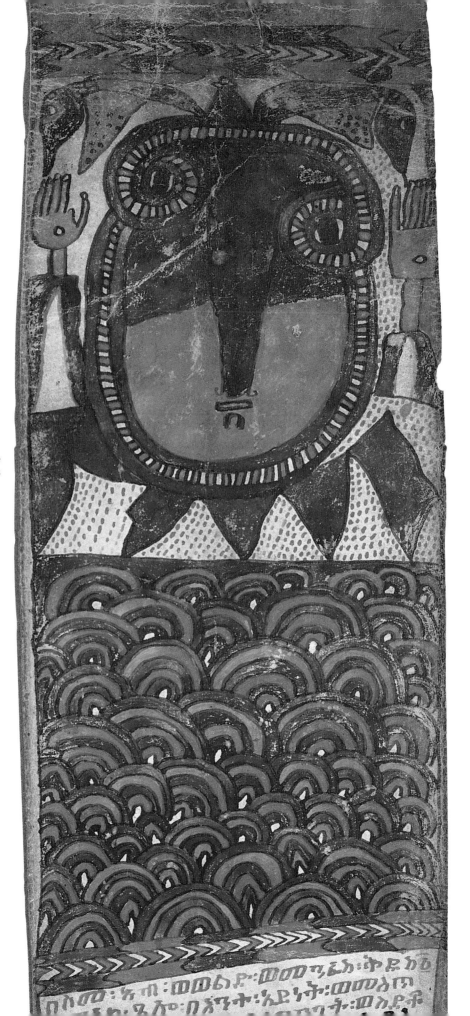

Fig. 26

Demon (?), detail of a prayer scroll, Ethiopia, 19th century, ink on parchment, 10¼ x 4½ in (26 x 11.5 cm), Musée National des Arts d'Afrique et d'Océanie, Paris

A winged serpent is wound around the face and the eyes of the central figure. The image derives ultimately from the Greek Gorgon, a face bristling with snakes. This type of demon-like creature was often painted on prayer scrolls and shown to people who were thought to be possessed by devils

mere remnant from the past, but is an image rooted in the Ethiopian medical context. Nowhere else in the world is illness so consistently interpreted as possession by a spirit. One can be possessed by devils, witches, or even by benevolent spirits. The imagery of scrolls became part of this process of interpretation. Commonly, a scroll image is placed before the eyes of the sick person, who is forced to look at it: at this moment the spirit, which was hidden inside his or her body, shouts and starts speaking. The image itself does not create the trance-like state, but is rather a graphic embodiment of the trance. This practice of staring at images has generated the specific style of Ethiopian scroll art. One finds it not only in the Gorgon-like figures, but in a wide range of images, the most striking of which is the serpentine figure of Gog and Magog that, at its best, is a pure and concentrated gaze. The figure, reduced to pairs of large eyes surrounded by a pattern of tiny arcs or scales, evokes a trance-like state and the notion of possession. Indeed, these large eyes draw their power from the patient's gaze and then direct this power back toward the patient. Images of eyes are produced elsewhere in the world, but in no other country have they developed into an art of the gaze as they have in Ethiopia.

As observed in the arts of the cross, the manuscript, and the icon, the craftsmen of this great African nation created a strong artistic culture that encompassed a wide range of influences and styles while maintaining their own unique vision.

Notes

1 Budge 1898.
2 Munro-Hay and Juel-Jensen 1995.
3 Lepage 1997A.
4 Lepage 1973.
5 Gerster 1970.
6 'Safeguarding Religious Treasures of the Ethiopian
 Orthodox Church,' a project in the Tegray and Amhara
 regions, sponsored by the Patriarch, abuna Paulos, and
 financed by the European Commission.
7 Oxford University Research Laboratory for
 Archaeology.
8 Bidder 1958; Gerster 1970.
9 Lepage 1987.
10 Balicka-Witakowska 1997.
11 Lepage 1997B.
12 Mercier 2000, p. 80.
13 Chojnacki 1983, fig. 65.
14 Gerster 1970.
15 UNESCO 1961, pls. VII–XXI.
16 Heldman 1972.
17 Annequin 1990, pp. 86–87; Heldman 1994.
18 Translation, Getatchew Haile 1992, p. 171.
19 Mercier 1997, p. 75.
20 Getatchew Haile 1983A.

21 Mercier 1997, fig. 63; Mercier 2000, p. 63.
22 Heldman in *African Zion* 1993, cat. 91; Mercier 2000,
 pp. 84–91.
23 Chojnacki 1983, pp. 378–98.
24 Basset 1897, p. 307.
25 Chojnacki 1983, p. 319.
26 Beckingham and Huntingford 1954, pp. 103–7.
27 Chojnacki 1983, pp. 217–89; Mercier 2000, p. 118.
28 Mercier 2000, p. 129.
29 Leroy 1961. Comparative illustration in Heldman
 1993, cat. nos. 97–98.
30 *Religiöse Kunst Äthiopiens/Religiose Art of Ethiopia*
 1973, cat. 45.
31 British Library Or. 635.
32 Leroy 1967, pls. XXVI–XXX and L.
33 Heldman in *African Zion* 1993, cat. 102.
34 Chojnacki 1983, pp. 469–524.
35 Mercier 1999.
36 British Library Or. 590.
37 British Library Or. 533, in Leroy 1967, pls. XLI–XIL;
 British Library Or. 603, in Mercier 2000, pp. 178–79.
38 Leroy 1967.
39 Di Salvo 1999.
40 Mercier 2000, p. 187.

Fig. 27

Procession, accompanied by draped, or "dressed," crosses, to a church or holy site where the Epiphany ceremony is to take place

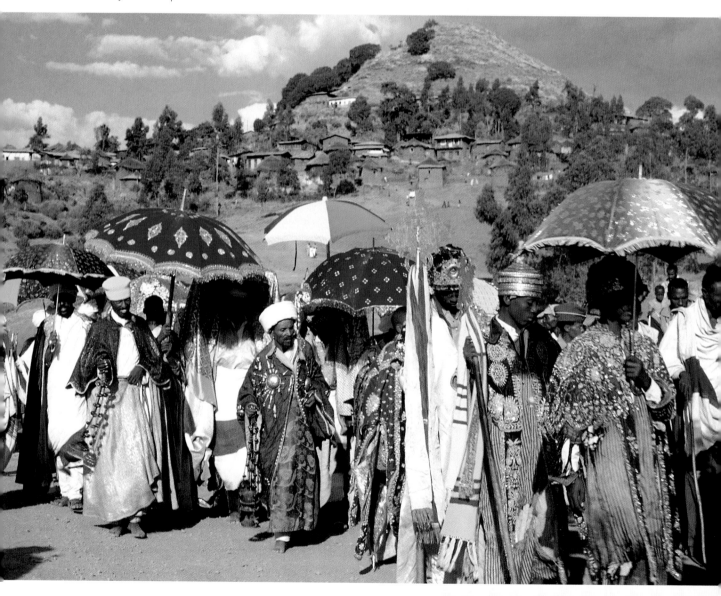

The Role of the Cross in Ethiopian Culture

C. GRIFFITH MANN
Zanvyl Krieger Curatorial Fellow
The Walters Art Museum

As an object sanctified by the blood of Christ, the Cross of the Crucifixion occupies a central place in Ethiopian culture and worship. Alluding to the hope of resurrection, the cross serves as a powerful symbol of triumph. Its function, however, is more complicated, as it also assumes a protective capacity, based upon its perceived ability to avert evil. The cross, therefore, occupies equally prominent positions within the church and the home.

Historically, the most important form of Ethiopian cross has been the processional cross (cat. 1–6). Surviving inscriptions indicate that individual patrons commissioned these crosses and bequeathed them to religious institutions in the hope of securing salvation.[1] As venerated objects, processional crosses continue to play a fundamental role in liturgical processions, church services, and sacramental activities. When in use, a hollow shaft allows each cross to be mounted on the end of a tall staff, thereby ensuring its visibility for worshippers. During processions, the pierced designs of these objects create dramatic silhouettes against the sky. Their variegated metal surfaces also reflect sunlight or candlelight, enhancing their resplendence. Because crosses symbolically represent the crucified figure of Christ, processional crosses were adorned, or "dressed," with rich fabrics when in use (fig. 27). As a result, the bases of all such crosses incorporate openings designed for securing these textiles while the crosses are carried along their processional routes.

Two other categories of crosses have survived in even greater numbers. Hand crosses (cat. 7 and 8) play a fundamental role in the healing of souls, and belong to individual priests rather than institutions. As is the case even today, priests use these objects in administering benedictions and absolutions, extending the cross to be kissed by their parishioners. Pectoral crosses (cat. 9) are suspended from a chord (*matab*) tied around the neck at the time of baptism. In addition to serving as a marker of Christian faith, these crosses are believed to offer protection to their wearers.

The early sixteenth-century travel narrative of Francesco Alvarez, chaplain of the Portuguese embassy to Ethiopia, describes a community of monks who made hand crosses for clerics and monks as well as pectoral crosses for the laity.[2] *The Life of Iyäsus Mo'a*, a thirteenth-century saint and abbot (died 1292), states that he made twenty-four lamps with his own hands for his monastery's church of Saint Stephen.[3] Such accounts suggest that religious communities regularly produced the instruments required for Christian worship, practicing their craft within the broader context of their spiritual vocation. The most significant difference between early and late crosses lies in the technique of their manufacture. Made predominantly of bronze, early crosses were cast according to the lost-wax method. The cross was first shaped in wax, which was then covered in clay and fired. During the firing process, the wax melted and flowed out of a hole in the clay mold, which preserved the impression of the wax original. When filled with molten metal, the mold transposed the imprint of the wax cross onto new material. Imperfections in the cast were subsequently filed, and incised decoration was sometimes added, resulting in a unique object each time.

1 *Religiöse Kunst Äthiopiens/Religious Art of Ethiopia* 1973, p. 194.
2 Alvarez 1961, vol. 1, p. 170.
3 Heldman 1994, pp. 80–81.

Cat. 1

Processional Cross

Ethiopia (Lasta?), 12th–13th century

Bronze

13¾ x 6⅛ in (35 x 15.5 cm)

54.2889, museum purchase, the W. Alton Jones Foundation Acquisition Fund, 1996

Cast as one piece, this cross dramatically testifies to the technical skill of the artisan responsible for its creation; it is also extremely rare because of its early date and fine state of preservation. Two simple, central crosses have been enclosed in a pear-shaped frame, a design prevalent in the area of Lasta, most famous for the rock-hewn churches of Lalibala (see fig. 9).[1] A third cross surmounts the crenellated exterior border, creating a vertical axis composed entirely of crosses. The pear-shaped arch that surrounds the central cross first appeared in processional crosses produced during the twelfth century.[2]

In addition to the complicated casting process, here combining open spaces and flame-like extensions, this cross has been inscribed with lively geometric decoration. With the exception of the circles, these lines were inscribed freehand upon the object, as the occasional irregularities in their patterning demonstrate. The texture created by these designs accentuates the play of light across the surface of the cross. At its very center, the detached arms of the central cross create the impression that it hovers in its opening. When displayed against the sky, the cross would, therefore, have resembled the sign of Christ as described in the Gospel of Matthew (24:30), where the emblem of the Son of Man appears in the heavens to announce the Second Coming. The shaft is a later replacement.

[1] Mercier 2000, p. 70.
[2] Moore in *Proceedings* 1989, p. 111.

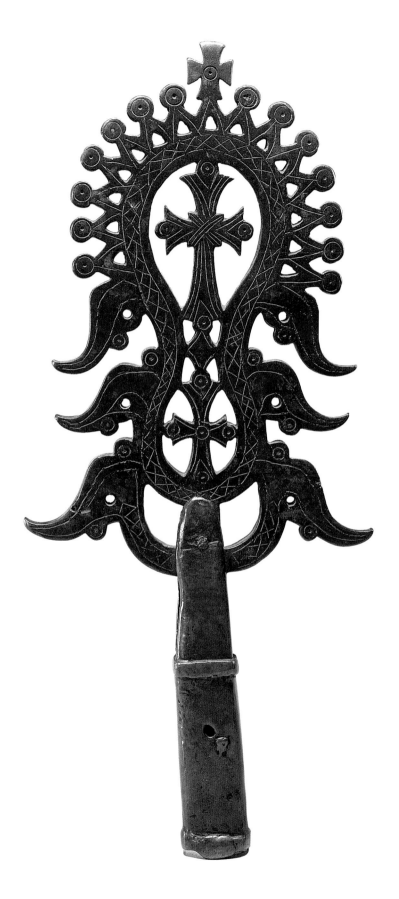

Cat. 2

Processional Cross

Ethiopia (Lasta?), 12th–13th century

Bronze

10 x 6¼ in (25.5 x 16 cm)

54.2891, museum purchase, the W. Alton Jones Foundation Acquisition Fund, 1996

The complicated design of this cross must have presented a considerable challenge to its creator, who cast its body as one piece. Simple incised borders sharpen and distinguish the individual components of the object. These lines, which were probably added freehand, provide a texture that animates the surface of the entire cross. The numerous perforations create an intricate silhouette, but also serve the practical function of conserving material and minimizing weight. The shaft, perhaps a later addition, was riveted to the base.

The foliate decoration of the cross, which simultaneously suggests birds and vegetation, creates a complex pattern around the small cross at the center. In Ethiopian art, birds often serve as heralds of the Resurrection, and their evocation here is therefore appropriate.[1] The multiple projections further strengthen the allusion to the rejuvenating power of the cross, as their tendril-like repetition conveys a sense of organic growth. The additional presence of three smaller crosses at the terminal points of the object reiterates this idea; the crosses spring like young buds from their supporting extensions.

[1] Mercier 1997, p. 71.

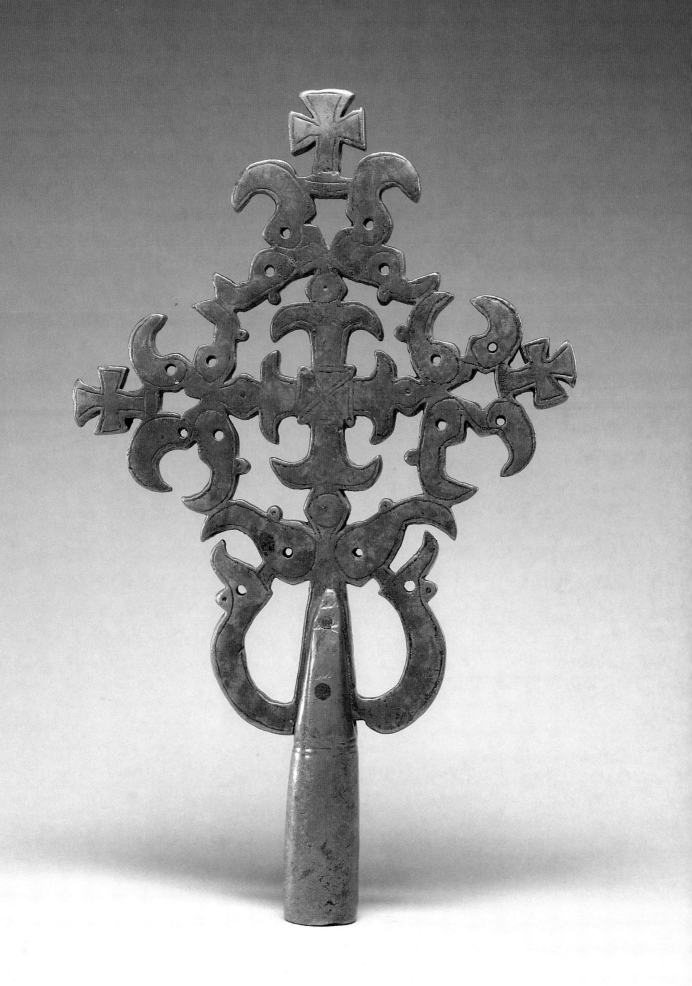

Cat. 3

Processional Cross

Ethiopia (Lasta?), 14th–15th century

Bronze

8 ¾ x 6 ⅞ in (22.3 x 17.5 cm)

54.2890, museum purchase, the W. Alton Jones Foundation Acquisition Fund, 1996

This cross, which survives in nearly pristine condition, was cast in one piece, with the base and body formed of the same material. The high degree of perforation, creating a radiating lattice of crosses, would have been difficult to achieve in any other medium. Because of its inherent strength, bronze was ideally suited to this kind of treatment. The design is rigorously geometric, dominated by the interaction of circular and cruciform shapes. The curving ribbons enclosing the central cross differentiate this space from the concentric rings around it. The central cross, therefore, remains the focus of the object, and is further distinguished by its open-work construction. The many small crosses radiating out from the hub of this wheel-like form allude to the symbolic, regenerative properties of the cross.

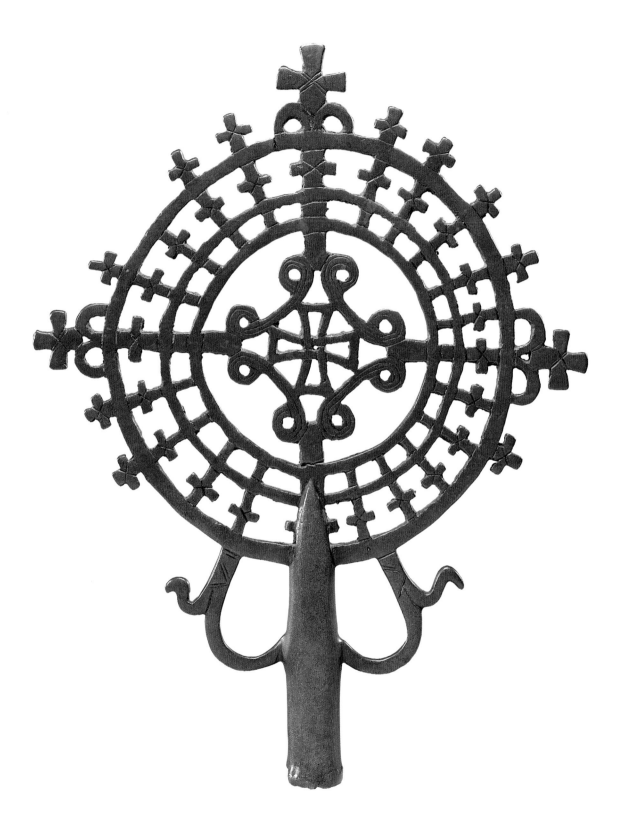

Cat. 4

Processional Cross

Ethiopia, 15th century

Bronze

10¼ x 6⅛ in (26 x 15.6 cm)

54.2894, museum purchase, the W. Alton Jones Foundation Acquisition Fund, 1996, from the Nancy and Robert Nooter Collection

The exceptional quality of this cross demonstrates the high level of technical skill attained by the monastic artisans of the fifteenth century. Its multiple openings create a complicated pattern comprised of nine interlocking circles enclosed within a quatrelobe frame. Intricate ribbon-work fills the boundary between this frame and the circular shapes of the interior. Fine linear decoration completes the design and accentuates the delicate appearance of the composition.

At the outside edges of the terminal points of the cross, intertwining lines end in serpentine curves. The snake-like forms assume a more distinct shape on either side of the looping brackets that secure the cross to its base. Such details possibly incorporate references to the brazen serpent of Moses as described in the *Book of Numbers* (21:4–9).[1] In the wake of a devastating plague of poisonous snakes, God instructed the Israelites to erect a brass serpent upon a pole. Because gazing upon this object was believed to cure those bitten, Christians interpreted the brazen serpent as a prefiguration of the redemptive Cross of Christ.

The three large crosses at the terminal positions, each of which features linear decoration, appear to emerge, plant-like, from the diamond-shaped supports that connect them to the frame. The organic shape of these details alludes to the sprouting leaves of the Tree of Paradise, an object with which the cross was often associated.[2] The perforated crosses that flank the shaft would have secured the fabric with which the cross was draped, or "dressed," for processions. Although a stylistically comparable cross in the collection (fig. 28) testifies to the popularity of this design, the intricate patterns and brilliant execution of this example make this one of the most important crosses to exist outside of Ethiopia.

[1] Godet in Mercier 2000, p. 67.

[2] Mercier 1997, p. 71.

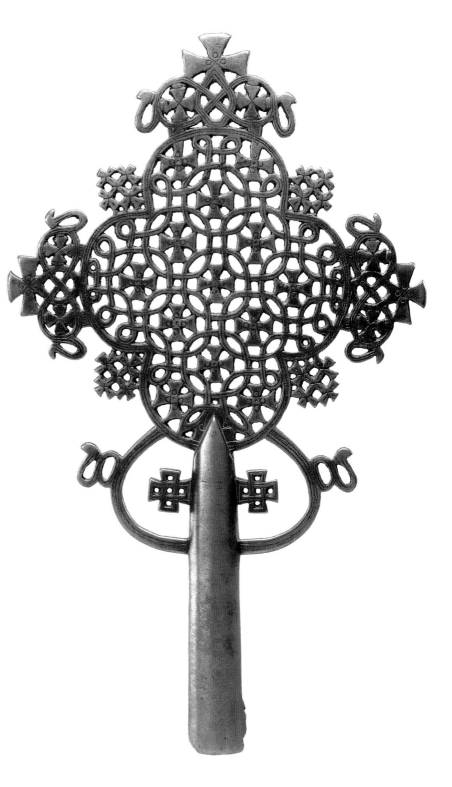

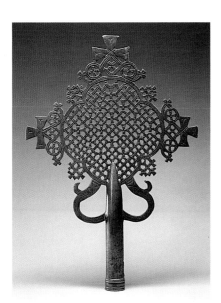

Fig. 28

Processional cross

Ethiopia, 15th century, bronze,
13 ¹³⁄₁₆ x 9 ⅝ in (35.1 x 24.6 cm),
54.2942, gift of Nancy and Robert
Nooter, 1997

Like the accompanying cross, the body
of this piece is similarly constructed of
a pattern of interlocking circles. The
incised lines at the intersection of
vertical and horizontal elements
create thirteen small crosses out of
the interlaced design of the body

Cat. 5

Processional Cross

Ethiopia, 15th century

Bronze

9¼ x 5½ in (23.5 x 14 cm)

54.2892, museum purchase, the W. Alton Jones Foundation Acquisition Fund, 1996

In a design typical of the fifteenth century, this cross uses an interior panel to represent sacred figures.[1] Because it has been cast as a single piece with the shaft, it is likely that this cross represents a relatively early example of the form. The incised central panel features an image of Mary and the infant Christ on one side and the figures of two archangels on the other. The picture field, consisting of a short-armed cross, is surrounded by an interlacing web terminating in small crosses. The incised linear decoration accentuates the woven character of the design, conveying the impression that individual bands pass over and under each other as they encircle the central panel.

The cross's incorporation of an image of the Virgin Mary, whose veneration was formalized under Emperor Zär'a Ya'eqob (reigned 1434–68), suggests that the object combined the functions of processional cross and icon. Krestos Sämra, a female saint who founded a monastery on Lake Tana in the mid-fifteenth century, often prayed holding a cross that featured a picture of the Virgin and Child. On one occasion, as she held the object in her hand, Christ spoke to her through his likeness, saying: "Do not hold my head!"[2] Although the object featured in this story might have been a hand cross, such accounts demonstrate that by the fifteenth century the devotional function of icons had radically influenced the traditional design of the processional cross.

[1] Moore in *Proceedings* 1989, pp. 112–13.
[2] Heldman 1994, pp. 170–71.

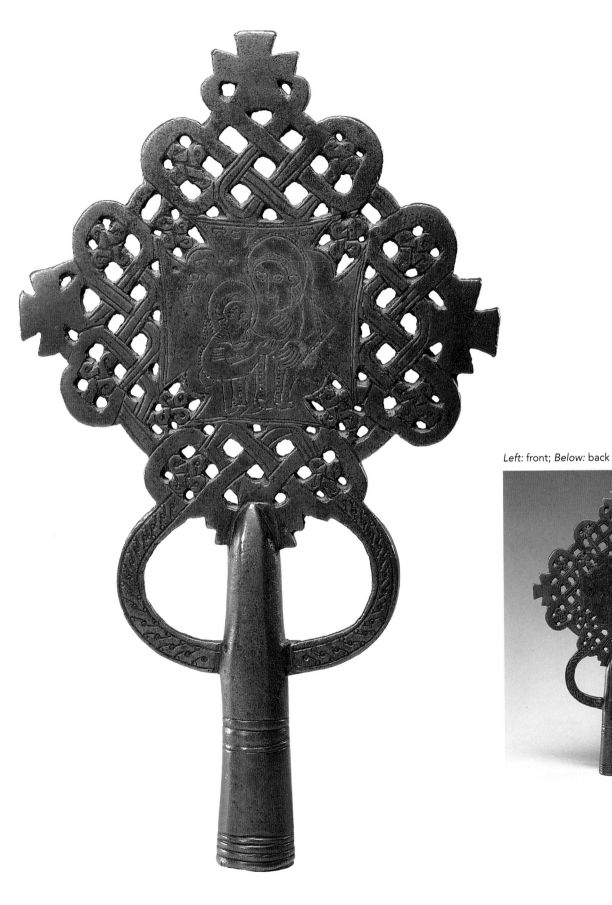

Left: front; *Below:* back

Cat. 6

Processional Cross

Ethiopia (Gondar), late 18th century

Brass

20⅞ x 13¾ in (53 x 35 cm)

54.2893, museum purchase, the W. Alton Jones Foundation Acquisition Fund, 1996

Although brass gradually replaced bronze as the primary material for crosses during the fifteenth century, crosses with incised figural decoration on the arms as well as the central panel did not appear until the Gondarine period (see cat. 15).[1] Unlike the earlier crosses, which were cast using the lost-wax technique (see p. 75), the separate components of this cross were cut from a flat sheet and welded together. The cross is, therefore, composed of three separate pieces that have been riveted to the shaft. The two lower arms supported the fabric dressing required for all processional crosses. Their attachment to the transverse arms of the main cross, which was considerably wider than its predecessors, stabilized the entire object.

The front of the cross features Our Lady Mary with her Son, Saint George, Saint Täklä Haymanot, and a prostrate donor. The back depicts the Crucifixion, the Entombment, the Resurrection, and two unidentified saints. The incised decoration of these scenes reveals a sureness of line that is indicative of the control the artisan exercised over his medium.

Täklä Haymanot (ca.1214–1313), one of the most important monastic saints in Ethiopia, appears here with a broken leg, an injury he sustained during extended hours standing at prayer. Before Täklä Haymanot is the cross's patron, who assumes the prostrate position reserved for donor figures. The presence of the patron demonstrates that the cross was commissioned as a votive object, and was perhaps presented to one of the many churches in the vicinity of Gondar.

[1] Moore in *Proceedings* 1989, p. 111.

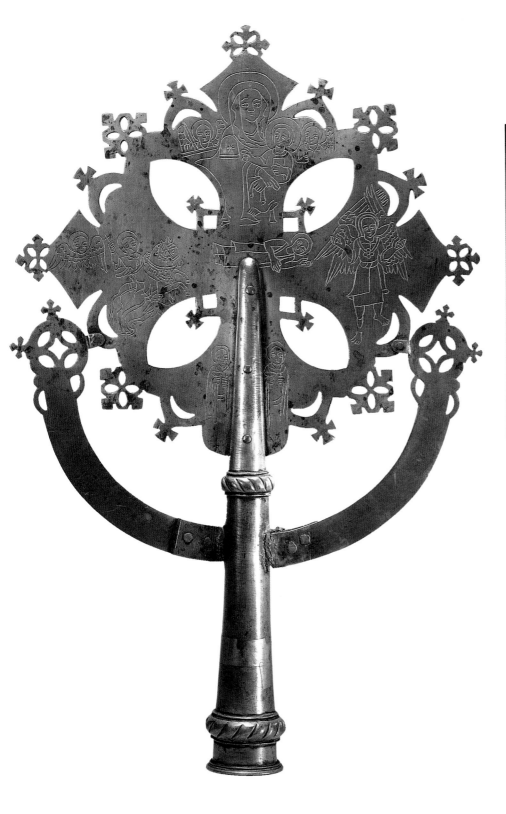

Left: front; *Above:* back

Cat. 7

Hand Crosses

Ethiopia, 13th–15th century

Iron

(left) 13¼ x 3 in (34 x 7.6 cm);
(right) 14¾ x 4⅛ in (37.4 x 10.4 cm)

(left) 52.297; *(right)* 52.296, gift of Nancy and Robert Nooter, 1997

Metal hand crosses are typically constructed from silver, brass, or iron that has been hammered into shape rather than cast using the lost-wax method (see p. 75).[1] These objects draw their formal inspiration from processional crosses, and their creators often imitated styles that had been developed at great religious centers such as Lalibala.[2] The formal relationship of the pierced hand cross to latticework processional crosses (see cat. 4) is evident in the drilled holes of its body, an attempt to imitate the form of the larger objects. Although their reliance on pre-existing models makes metal hand crosses difficult to date, these objects were an important means of transmitting local styles, particularly as they were designed to be portable.

Because these crosses were regularly used in the daily lives of Ethiopian priests, they were exposed to a greater degree of wear, and they often reveal evident signs of use. The scratches that mark the surface of the cross on the right testify to its service in the hands of its owner. This cross is unusual because it has been cast in the round rather than hammered flat, like most other Ethiopian hand crosses. Its modeled arms eloquently display the simplicity of the designs that characterize these objects, while the fluting along the shaft adds an element of refinement. Its round base, another point of divergence with traditional designs, suggests an early date.

[1] Moore in *Proceedings* 1989, p. 113.
[2] Hecht in *Proceedings* 1989, pp. 116–17.

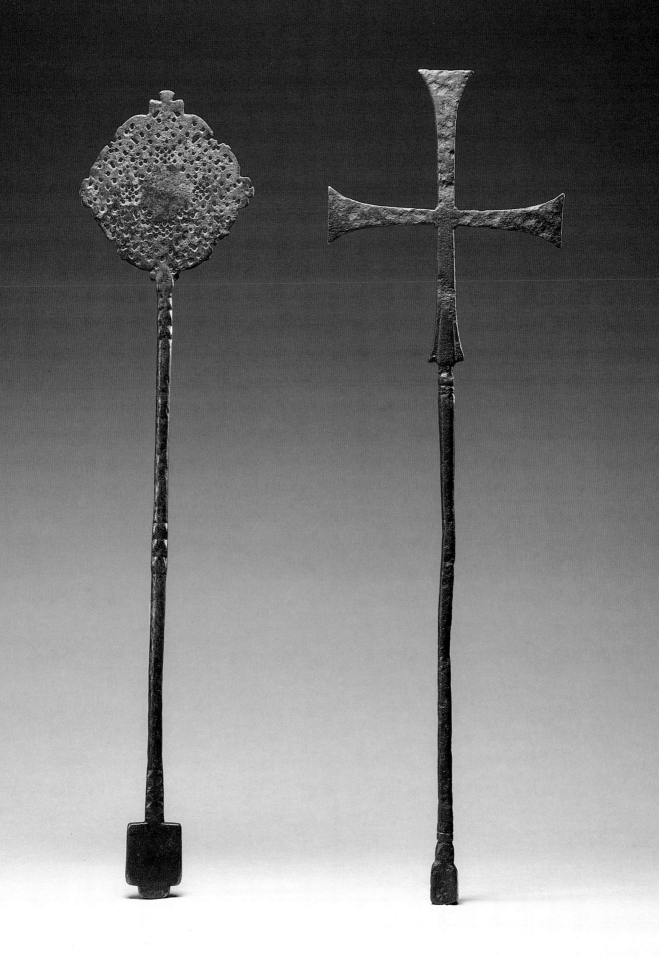

Cat. 8

Hand Cross

Ethiopia, 18th–19th century

Wood

13⅜ x 4¼ in (34 x 10.7 cm)

61.340, gift of Nancy and Robert Nooter, 1997

Hand crosses incorporating human figures are extremely rare and appear to have been executed exclusively in wood. Such figures are sometimes identified as Christ or Adam.[1] As is typical when human forms are carved as part of the shaft, the torso and legs of the figure double as the handle of the cross. Three points of contact between the figure and the cross, both sculpted from the same piece of wood, ensure the structural integrity of the object.

The material used in creating this type of cross, which was often carved by the priest who used it, evoked the wood of the Cross upon which Christ was crucified. The elaborate interlace of the cross the figure holds must have presented a considerable challenge to the carver, as it had to be created without compromising the structural integrity of the whole piece. Created by drilling holes through the wood and carving linear elements into its surface, this design transformed the overall shape of the cross into a delicate web. Another wooden cross in the collection (fig. 29) has a more conventional design. However, the cross in the center of this object appears in silhouette. As a result, during benedictions this opening could be used to project a cruciform shadow onto the object or person receiving the blessing. The rectangular blocks at the bases of both crosses may be interpreted as references to the *tabot*, or carved altar box, venerated by Ethiopian Christians.

[1] Hecht in *Proceedings* 1989, pp. 118–19.

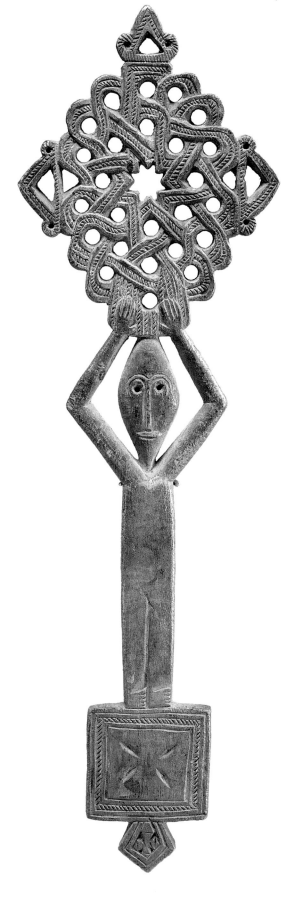

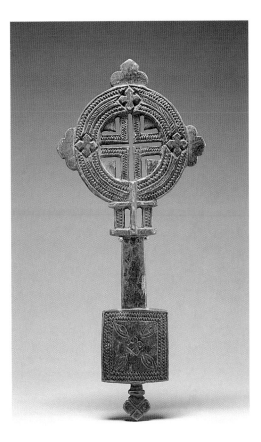

Fig. 29

Hand cross

Ethiopia, 18th–19th century, 14 ½ x
6 ¼ in (37 x 16 cm), 61.342, gift of
Richard Hubbard Howland, 1998

Cat. 9

Pectoral Crosses

Ethiopia, 19th century

Silver, tin, copper alloys, some silver- or tin-plated or with washes

row 1: (a) 1 ⁷⁄₁₆ x 1 in (3.6 x 2.5 cm);
row 2: (b)1 ⁹⁄₁₆ x 1 ½ in (4 x 3.8 cm); (c) 2 x 1 ¹³⁄₁₆ in (5 x 4.6 cm); *row 3:* (d) 2 ¼ x 1 ½ in (5.7 x 3.8 cm); *row 4:* (e) 2 ⅜ x 1 ⁷⁄₁₆ in (6 x 3.6 cm); (f) 2 ⁷⁄₁₆ x 1 ⁵⁄₁₆ in (6.2 x 3.3 cm)

row 1: (a)57.2254.24;
row 2: (b)57.2254.53; (c)57.2254.4;
row 3: (d)57.2254.35;
row 4: (e)57.2254.17; (f)57.2254.54, gift of Mrs. Lily Mobille-Pappas, 1997

Pectoral crosses, which typically date from the late nineteenth and early twentieth centuries, exhibit a rich variety of forms. Ranging from simple Latin and Greek crosses to more elaborate examples with applied filigree and incised decoration, these crosses survive in great number.[1] Made of silver or other metals, these crosses were frequently created in molds. Those crosses that were cut from flattened metal sheets were typically embellished with incised or applied decoration.

These objects testify to the important position occupied by the cross in the daily lives of Ethiopian Christians. Such crosses were often suspended from the chord *(matab)* tied around a Christian's neck at the time of baptism. Their use is documented as early as the fifteenth century, when the Emperor Zär'a Ya'eqob decreed that every Christian should wear a neck cross.[2] As personal talismans, these objects were believed to protect their wearers from harm.

[1] Mercier 2000, p. 190.
[2] Moore 1973, p. 81.

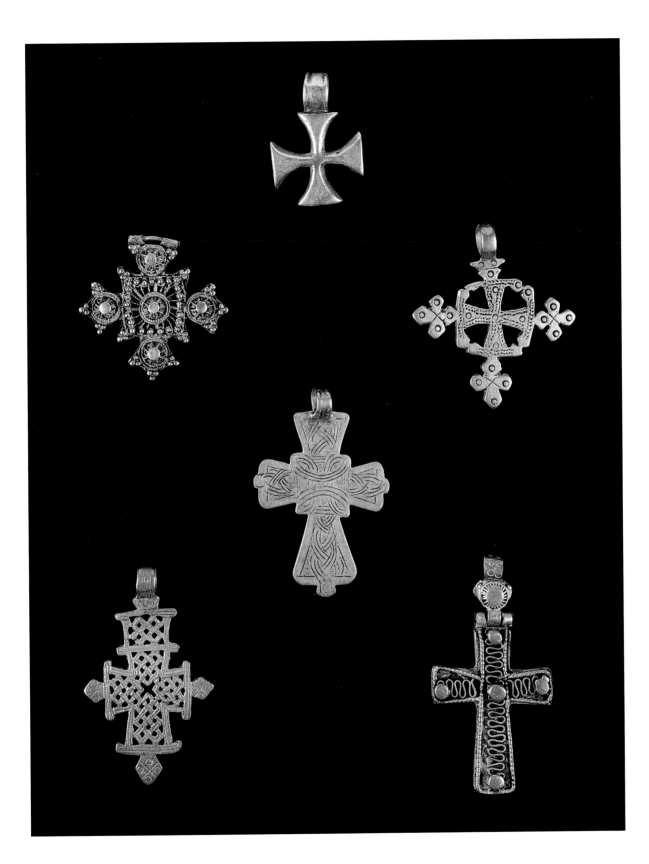

The Role of the Illuminated Manuscript in Ethiopian Culture

C. GRIFFITH MANN
Zanvyl Krieger Curatorial Fellow
The Walters Art Museum

The adoption of Christianity by the Ethiopian emperor Ezana during the fourth century effectively transformed Ge'ez, the classical language of the Aksumite empire, into the literary language of the Ethiopian Church. Although no longer widely spoken by the twelfth and thirteenth centuries, this language has survived to the present day in the same way that Latin has remained the authoritative language of the Roman Catholic Church.[1] The Gospel books (cat. 10 and 14), doctrinal texts (cat. 16), service books (cat. 15), devotional aids (cat. 18), and magical writings (cat. 19) fundamental to the practice of religion in Ethiopia testify to the wide range of functions assumed by Ge'ez texts.

Produced entirely by hand, Ethiopian manuscripts eloquently exhibit the time and labor involved in their creation. The parchment used to produce these books was obtained from animal skins that were washed, stretched, scraped, and dried to create suitable writing material. When ready, parchment was cut to the required size and lined in preparation for writing. These lines, which were incised into the surface of the parchment with a blunt instrument, often remain visible beneath the text. Once a sufficient collection of prepared parchment was assembled, the scribe began the work of copying and writing out the entire text with a reed pen (*bere*). Because no cursive form of Ge'ez exists, copying religious texts was a laborious process, requiring the scribe to lift his *bere* from the surface of the parchment between every letter. Generally, red ink was reserved for the opening lines of a text, new chapter-headings, and names. Once complete, the text leaves were assembled into gatherings, much like a modern newspaper, and sewn together with thread. The stacked gatherings were then chain-stitched to each other and bound between wooden boards (cat. 16). A single

manuscript, therefore, represents a considerable expenditure of materials and labor, requiring scores of animal skins and months of dedicated copying. From a very early period, the reproduction and embellishment of religious texts remained one of the primary responsibilities of monks and priests. The fifteenth-century *Life of Abbot Maba Seyon* describes how, as a young boy, the saint entered a monastery where he learned to write and paint.[2] Such references suggest that scribes at times doubled as illuminators. Perhaps most importantly, they also indicate that a monk's religious education often included artistic training, falling under the rubric of "spiritual work."

The first great centers of manuscript production in Ethiopia emerged in regions already renowned as monastic enclaves, particularly Lake Tana (cat. 11–13) and Gunda Gunde (cat. 14 and 17). Examination of the illuminated books these communities produced reveals a certain unity of artistic practice. Before the mid-sixteenth century, Ethiopian illuminators regularly composed their miniatures, or paintings, on blind-ruled grids. These lines, which are often visible beneath the paint, created a compositional structure specific to each illumination. Because scribes similarly used ruled lines to arrange their texts, this method of making pictures suggests a fundamental connection between writing and illumination. The marriage between the structural discipline of the scribe and the graphical sensitivity of the painter resulted in pictures of exceptional vitality. Later painters, particularly those working in the environs of Gondar (cat. 15 and 18), which emerged as the center of the imperial court toward the end of the seventeenth century, abandoned this approach, and instead combined pictures and texts on the same page without ruling the parchment specifically for illumination.

1 Getatchew Haile in *African Zion* 1993, p. 47.
2 Budge 1898, p. 32.

Fig. 30

The Evangelist Mark, detail from W.850, fol. 60v (cat. 14)

Cat. 10

Gospel Book

Ethiopia (Tegray), 14th century

Tempera and ink on parchment, bare wooden end boards

10½ x 6¹¹⁄₁₆ in (26.7 x 17 cm), 248 ff.

W.836, museum purchase, the W. Alton Jones Foundation Acquisition Fund, 1996, from the Nancy and Robert Nooter Collection

This Gospel book belongs to a group of manuscripts produced at a monastery in northern Ethiopia during the fourteenth century.[1] All of the surviving books in this group contain frontispieces featuring scenes of the Crucifixion, the Holy Women at the Tomb, and the Ascension. As with this example, the arrangement of the miniatures ensured that the Crucifixion and the Holy Women at the Tomb occupied facing pages. Close examination of the miniatures reveals that each picture was composed with the help of a specially designed grid, with the vertical lines clearly visible in the lower margins of both illuminations.

Both of these illuminations combine events from Christ's life with purposeful allusions to the holy sites in Jerusalem. On the left, the Crucifixion includes such historical characters as the two thieves and the soldiers, but avoids depicting the body of Christ, substituting instead the sacrificial Lamb of God, depicted above the central cross. The jeweled cross recalls a similar object in the chapel of Golgotha, which marked the site of the Crucifixion. The pillars that frame this scene further evoke the architecture of the chapel. Similarly, the narrative of the Holy Women at the Tomb unfolds beneath a domed structure representing the Church of the Holy Sepulchre that was erected over Christ's tomb. Because identical schemes appear on souvenirs made for pilgrims in Palestine during in the sixth and early seventh centuries, some scholars have suggested that the Byzantine cult of sacred sites inspired this iconography.[2] These illuminations were intended to call to mind the monuments erected to commemorate Christ's life, in this case to reinforce the authenticity of the texts they introduced.

[1] Heldman in *African Zion* 1993, cat. nos. 54–56; Mercier 2000, pp. 44–45.
[2] Heldman in *African Zion* 1993, p. 130.

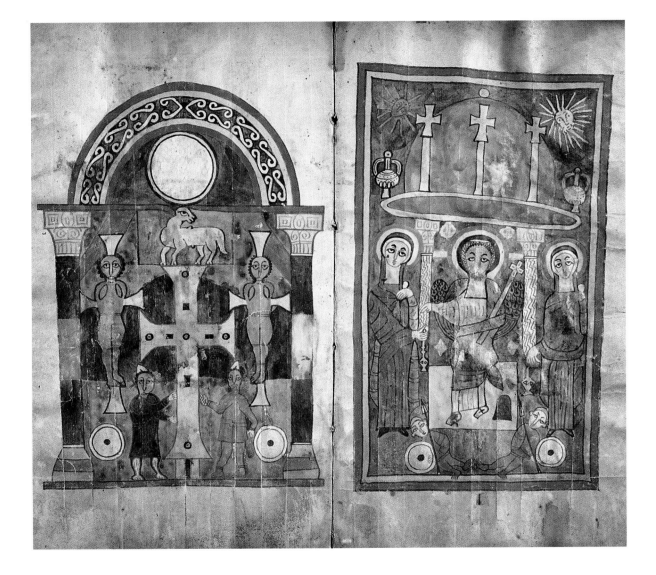

Cat. 11

Gospel Fragment

Ethiopia (Lake Tana), late 14th century

Tempera and ink on parchment

15 1⁄16 x 10 5⁄8 in (38.2 x 27 cm)

W.839, gift of Mr. and Mrs. Joseph Knopfelmacher, 1996

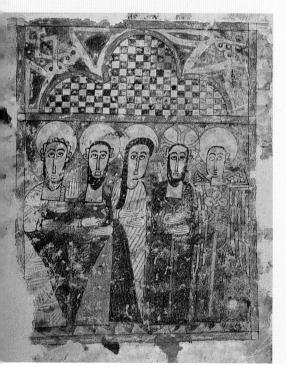

Decorated on both sides with narrative pictures, this detached leaf originally belonged to the prefatory cycle of a Gospel book. Its two sides, therefore, feature sequentially related events. On the original recto, or front, Joseph and Nicodemus, who are identified in the inscription, carry Christ's shrouded body toward a tomb framed by the recumbent bodies of two guards. The scene takes place beneath a lamp suspended from an opening. On the other side of the leaf, Christ, recognizable by his cruciform halo, appears with the archangel Michael before Mary Magdalene, John, and Peter. Inscriptions on the same scene in other manuscripts indicate that this side of the leaf depicts Christ announcing his Resurrection.[1]

Intact Gospel books with comparable versions of these two illuminations contain picture cycles of the life of Christ that extend from the Annunciation to the Ascension.[2] The Walters' leaf would, therefore, have originally appeared between folios depicting the Crucifixion and the Ascension. The leaf is thought to have been made in the Lake Tana region as it shares important stylistic connections with manuscripts produced in the monastic communities on the lake's islands.

[1] Skehan 1954, p. 354.
[2] These intact Gospel books are at The Metropolitan Museum of Art (1998.66) and the J. Pierpont Morgan Library (Morgan M828).

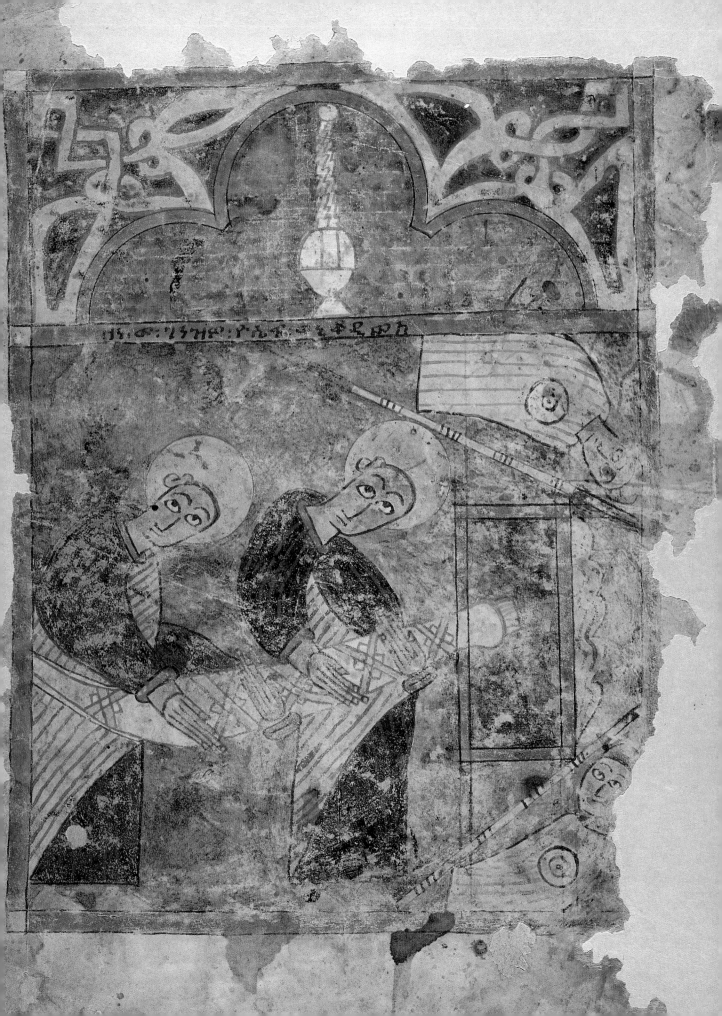

Cat. 12

Portrait of Saint Luke

Ethiopia (Lake Tana), late 14th–early 15th century

Tempera and ink on parchment

13¾ x 9¹³⁄₁₆ in (35 x 25 cm)

W.840, gift of Mr. and Mrs. Joseph Knopfelmacher, 1996

This detached leaf, which features the seated Saint Luke, once belonged to a Gospel book. As is typical of such pictures, Saint Luke appears here as an Ethiopian scribe surrounded by the implements of his profession. Two ink horns, one for red and one for black ink, appear together with a small pitcher in front of Luke's knees. The rectangular compartment above these objects contains three extra reed pens and a knife. Although these details fill the picture with familiar implements, Luke's upturned eyes provide an important reminder of the divine inspiration of his Gospel text.

The picture retains enough of its decoration to provide a clear sense of its original appearance. The juxtaposition of flat fields of color with superimposed linear decoration enlivens the surface of Luke's garments. The painting style, which is characteristic of the late fourteenth and early fifteenth centuries, favors abstraction above naturalism, thereby preserving the flatness of the parchment surface. As its intact left edge indicates, the illumination originally occupied the back of a folio, and presumably faced a text page containing Luke's Gospel. The opening lines of his Gospel actually appear in red on the page upon which Luke writes. In order to create the illusion that he works on real parchment, the illuminator left the parchment under Luke's text unpainted.

The regularly spaced horizontal lines visible throughout the page indicate that this leaf was originally lined in preparation for writing, in two columns of thirty-one lines. The page featuring Saint Luke was therefore only subsequently adapted for the picture, with the ruling alternately suppressed and exploited in the creation of the composition. The circular edges of his halo and the trefoil arches above his head were created with the aid of a compass. The painter ensured that Luke's head occupied the center of the page by adapting its shape to fit between the vertical lines originally intended to separate the two text columns.

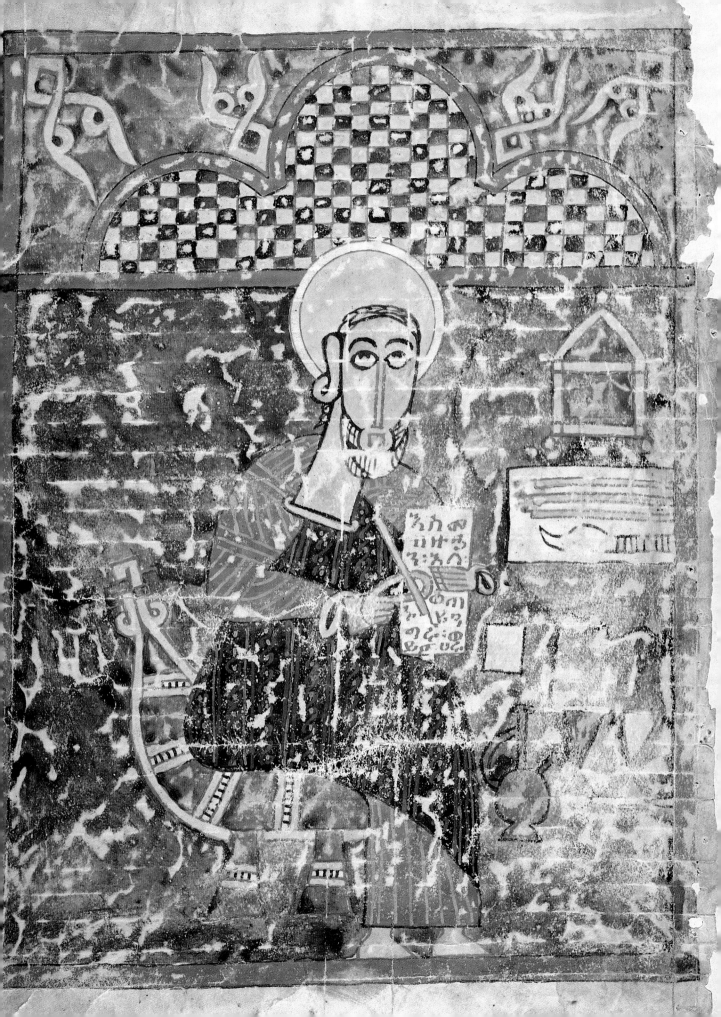

Cat. 13

Canon Tables

Ethiopia (Lake Tana), late 14th–
early 15th century

Tempera and ink on parchment

13⁷⁄₁₆ x 19¹¹⁄₁₆ in (34.5 x 50 cm)

W.838, gift of Mr. and Mrs. Joseph
Knopfelmacher, 1996

Presented within an architectural frame surmounted by birds, the tables inscribed on these pages are part of an ancient tradition and are found in Gospel books throughout the Christian world. Conceived in the fourth century by Bishop Eusebius of Cesarea, these charts, known as canon tables, provided readers with a concordance of the Gospel narratives. The vertical columns, each of which bears the name of one of the four Evangelists in its first compartment, contain numbers that correspond to particular passages in the text of the specified author. By moving horizontally across the page, readers could easily locate parallel passages from the Gospels. Moreover, because not all four Evangelists described the same events, the columns of individual canon tables steadily decline in number, beginning with four and eventually decreasing to one. The canon table therefore provided a cross-referencing system critical to reconciling the different accounts of Christ's life. Here, the number of rows dedicated to a single Evangelist sometimes extends into nearby columns, resulting in more than one column per Gospel.

With very few exceptions, the canon tables of Ethiopian Gospel books preceded the Gospel texts.[1] This leaf, which is decorated on both sides, therefore formed the heart of a gathering that originally contained the ten canon tables and perhaps even the beginning of a narrative cycle. The holes created in the leaf during the binding process remain visible in the gutter between the two sides of the parchment sheet. Interestingly, the measurements of the individual pages of this bifolium, or double-page spread, precisely match the dimensions of the portrait of Saint Luke (cat. 12). Their correspondence in size strongly suggests that these detached leaves originally belonged to the same book.

[1] LeRoy 1962, pp. 173–204.

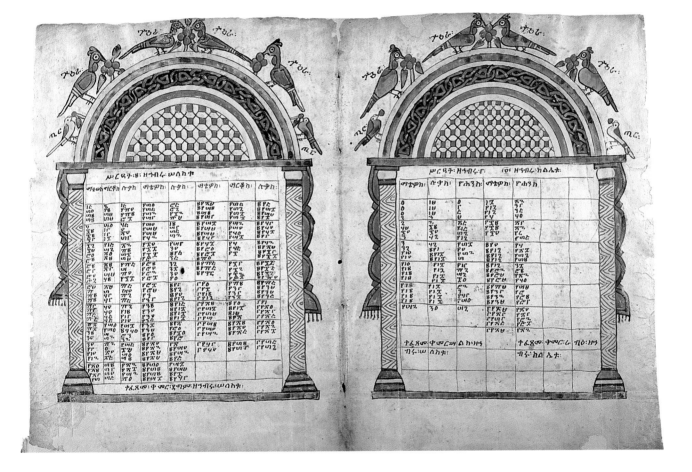

Cat. 14

Gospel Book

Ethiopia (Gunda Gunde), early–mid-16th century

Tempera and ink on parchment, bare wooden end boards

11¹³⁄₁₆ x 10 in (30 x 25.4 cm), 211 ff.

W.850, museum purchase, the W. Alton Jones Foundation Acquisition Fund, 1998

This Gospel book, which survives in nearly pristine condition, was produced by one of the most prolific monastic workshops of the late fifteenth and early sixteenth centuries. Located in the mountainous region of northeastern Ethiopia, the monastery at Gunda Gunde, which belonged to an order founded by the monk Esṭifanos in the fifteenth century, created a distinct tradition of book illumination.[1]

The opening of each Gospel features an Evangelist portrait and a text page surmounted by a complicated headpiece known as a *harag*, after the Ge'ez word for the tendril of a climbing plant (folio 154).[2] Sprouting crosses throughout its pediment, this decoration provides a monumental portal for the first page of the Gospel text. This kind of interlaced decoration, a testimony to the precise geometry of its construction, was a distinguishing characteristic of the monastic workshop at Gunda Gunde.

In addition to the four Evangelists portraits, this book also features seven full-page narrative pictures. Yet in contrast to the Gospel books produced a century earlier on the islands of Lake Tana, this book introduces narrative pictures into the body of the Gospel texts. These illuminations, which were inserted into the text as single leaves, feature key episodes from Christ's life. The first narrative picture in the text, depicting the Transfiguration, concludes Saint Matthew's Gospel (folio 59v). Described in the Gospels as appearing in shining white raiment, Christ's figure incorporates the light tone of the underlying parchment, which has been minimally decorated with fine lines. Also remarkable is the depiction of Moses and Elijah, who pull back the oval around Christ to reveal his divinity to the amazed disciples at the bottom of the page.

The Crucifixion, which occupies a position in the heart of Saint John's Gospel, has been arranged to create a pictorial dialogue between facing pages (folios 196v–197). Rendered on a monumental scale, Mary and John, who face the picture of the Crucifixion on the opposite page, provide a powerfully evocative image of grief. The ink lines beneath their eyes brilliantly convey their emotional state, streaking their cheeks with tears. The inscription above the figure of John, whose halo has been reduced to accommodate the text, invokes the protective power of their prayers, transforming the scene into a moving request for their intercession.[3]

[1] Heldman in *Proceedings* 1989, pp. 5–14; Mercier 2000, pp. 84–91.
[2] Zanotti-Eman in *African Zion* 1993, p. 63.
[3] The inscription reads: "A picture of the Mother of Our Lord and His disciple John, whom He loved, as they stood beneath the cross. May their prayers protect us. Amen."

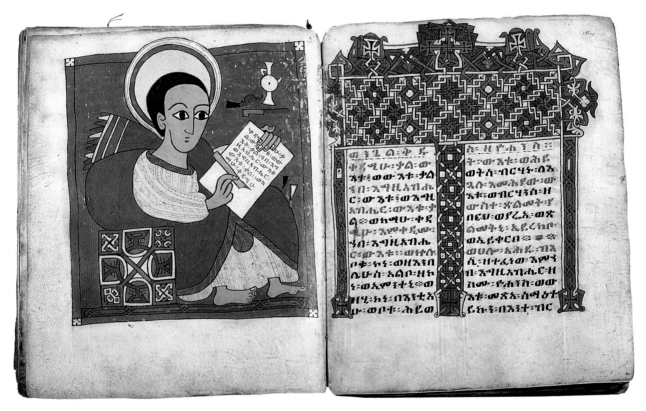

Folios 153v–154

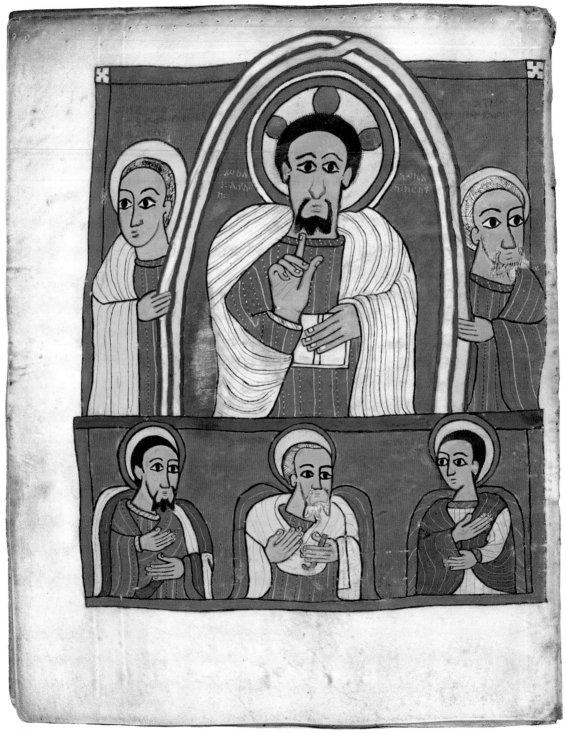

Folio 59v

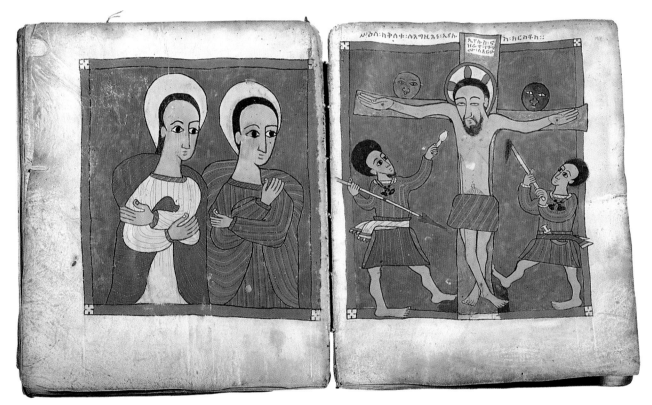

Folios 196v–197

Cat. 15

Homiliary and Miracles of the Archangel Michael

Ethiopia (Gondar), late 17th century

Tempera and ink on parchment, fabric-covered wooden end boards

10¼ x 9¼ in (26 x 23.5 cm), 127 ff.

W.835, museum purchase, the W. Alton Jones Foundation Acquisition Fund, 1996

The establishment of a permanent court center at Gondar by the Solomonic emperor Fasilädäs (reigned 1632–67) marked the beginning of a period of tremendous cultural productivity.[1] The presence of the court transformed the region into one of the most important centers of artistic production in Ethiopia, particularly with regard to painting. Imperial and aristocratic patrons commissioned monumental murals for the religious institutions they founded and supported, and incorporated their taste for extensive picture cycles into illuminated manuscripts. Featuring nearly fifty full-page illuminations, this manuscript is a pristine example of the lavishly illustrated books commissioned by both private and institutional patrons during this period.

The archangel Michael, whose cult first emerged under the patronage of the Emperor Zär'a Ya'eqob, remains the most venerated archangel in Ethiopia, largely due to his role as an intercessor on behalf of the faithful. This manuscript combines the monthly liturgical commemoration of Michael with narrative scenes of his miracles. Successive portions of the book, essentially a compilation of sermons, were read aloud on particular feast days.[2] In one of the first monumental illuminations, Saint Michael rescues the faithful from the flames of Hell, while those already saved are depicted in paradise on the facing page (folios 10v–11). The archangel's role in biblical history is featured later in the book, where he appears as one of the primary characters of the Moses story (folio 59). Standing to the right of the burning bush, he speaks to Moses, whose bare feet indicate the sacred status of the ground on which he stands. Immediately below, Michael instructs Moses to touch his staff to the Red Sea, thereby drowning Pharaoh and his army. In one of the most impressive openings of the book, God the Father, appearing together with the Twenty-Four Elders, faces the archangels Michael and Gabriel (folios 89v–90). The minutely rendered textiles in these pictures suggest a connection with the fashions of the Gondarine court and indicate that the painters depicted their scriptural subjects using a visual language rooted in contemporary culture.

The neutral ground of these paintings is a characteristic feature of early Gondarine manuscripts.[3] In contrast to their fourteenth- and fifteenth-century predecessors, the painters who produced these pictures did not blind-rule their pictorial compositions (see cat. 10). On the contrary, the horizontal lines visible throughout the pictures indicate that they worked on parchment sheets originally prepared for writing. The fact that they ignored rather than adapted these lines, a significant departure from previous traditions, suggests that Gondarine painters were not necessarily trained exclusively as manuscript illuminators. It is, therefore, not surprising that their pictures often demonstrate stylistic links with contemporary mural painting.

[1] Heldman in *African Zion* 1993, pp. 193–97; Mercier 2000, pp. 122–23.
[2] Appleyard 1993, cat. 58 and 96.
[3] Heldman in *African Zion* 1993, p. 195.

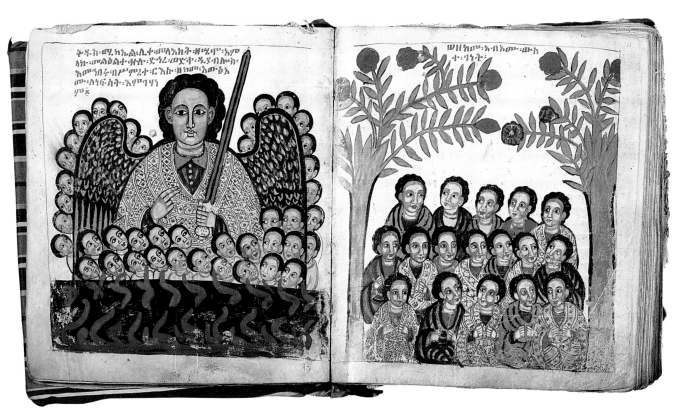

Folios 10v–11

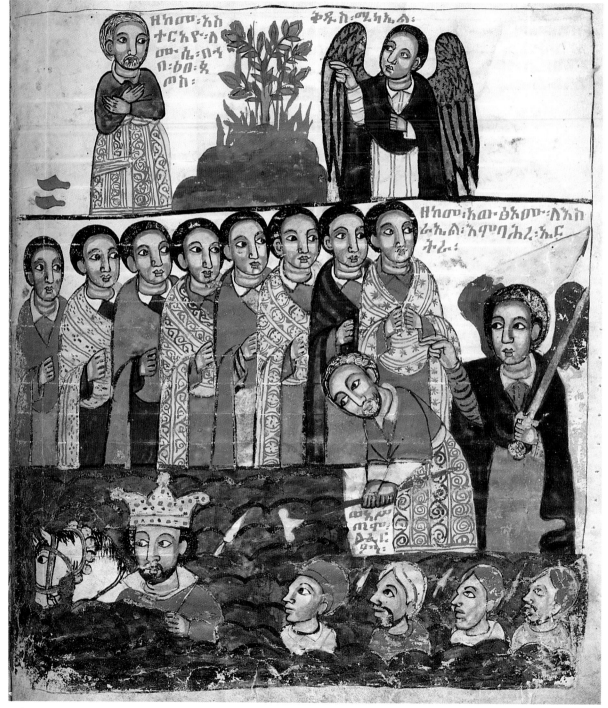

Folio 59

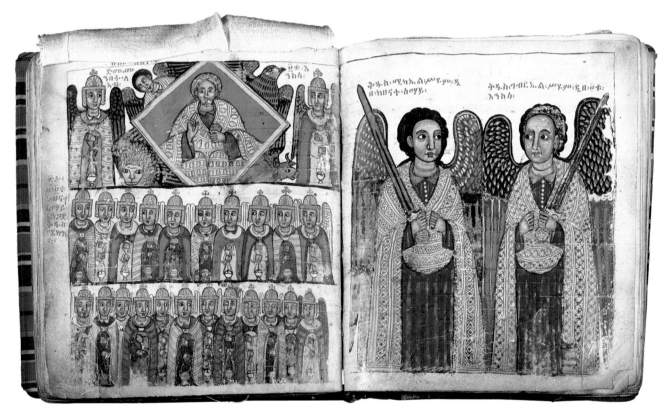

Folios 89v–90

Cat. 16

Prayer Book with Leather Satchel

On the Trinity

Ethiopia, 19th century

Ink and tempera on parchment, wooden end boards, leather satchel

5⁵⁄₁₆ x 3⅞ in (13.5 x 9.8 cm), 84 ff.

W.784, museum purchase, 1976

This small prayer book, which still retains its original leather carrying case, provides an excellent example of a manuscript designed for private use. The text features collections of hymns and accounts of miracles associated with the Trinity. Their arrangement creates a devotional sequence, with specific readings provided for each day of the week. The insertion of colored threads into pages that mark the beginning of a particular day of prayer allowed the owner to find his place quickly. The exposed spine of the manuscript permits a clear view of the nine gatherings of eighty-four parchment leaves used to create this book. Chain-stitched thread connects the gatherings to each other and to the wooden boards at either end of the text block, a standard Ethiopian binding practice.

The leather carrying case consists of two satchels that fit snugly one inside the other, securing and protecting the book. The attached straps allowed the book to be slung over its owner's shoulder during his travels. According to an inscription preserved inside the book, the original owner was a man called Täklä Maryam.

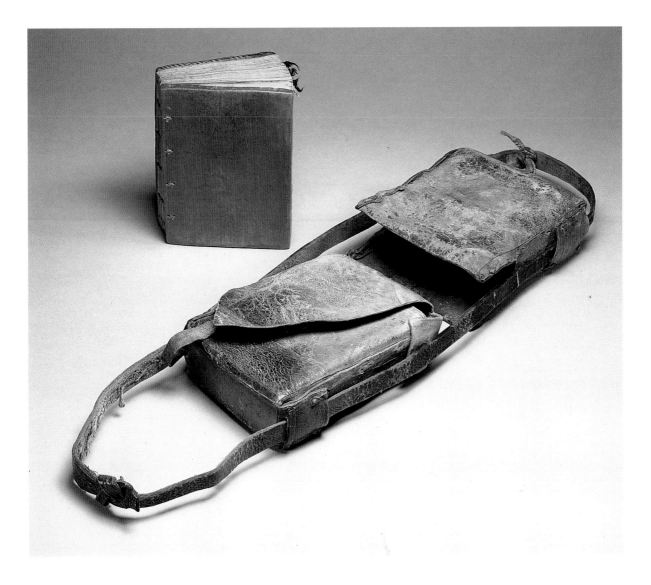

Cat. 17

Folding Processional Icon in the Shape of a Fan

Ethiopia (Gunda Gunde), late 15th century

Tempera and ink on parchment

24 ¼ x 154 ⅛ in (61.6 x 391.4 cm) extended; 24 x 4 ¹/₆ in (61.6 x 10.3 cm) single panel; 38 panels

36.9, museum purchase, the W. Alton Jones Foundation Acquisition Fund, 1996

Fig. 31

The Däbrä Seyon folding processional icon, with its two ends held together to form a full circle

Painted icons of this type are extremely rare, surviving only at the Walters, the church of Tana Cherqos on Lake Tana, and the church of Saint Mary at Däbrä Seyon. Painted on five sheets of parchment that have been stitched together and folded, thirty-eight identically sized figures span its surface. The deliberate variation of costumes and hand gestures creates an animated composition.

Only the principal nine figures have distinguishing inscriptions. Reading from left to right, they are: Juliet, Cyriacus, George, John the Baptist, Michael, Mary, Raphael, Paul, and Afnin. The unidentified figures are undoubtedly a combination of Old Testament patriarchs and prophets, as well as New Testament apostles and saints. The painting style of the figures exhibits close parallels with the illuminations of the Gospel book from Gunda Gunde (see cat. 14), suggesting that this object was also produced by a Stephanite monastery.

Although this object adopts the form of a fan, it is perhaps better understood as a folding processional icon. The Däbrä Seyon fan (fig. 31) provides a glimpse of what was originally a spectacular arrangement. The wooden panels at either end of the Däbrä Seyon fan indicate that, when not in use, the object was stored much like a book, with its folding leaves protected between paired covers. Yet when unfolded, the two covers came together to create the handle for a giant wheel that could be displayed during liturgical processions and church services.

Although lacking its original wooden covers, the Walters fan apparently preserves all of its original parchment panels, which, when unfolded, would have formed a circle roughly four feet in diameter. The Virgin Mary, whose hands are raised in a gesture of prayer, is then at the top of the wheel. By depicting Mary in the company of saints and angels, the icon powerfully evokes the celestial community of the church.

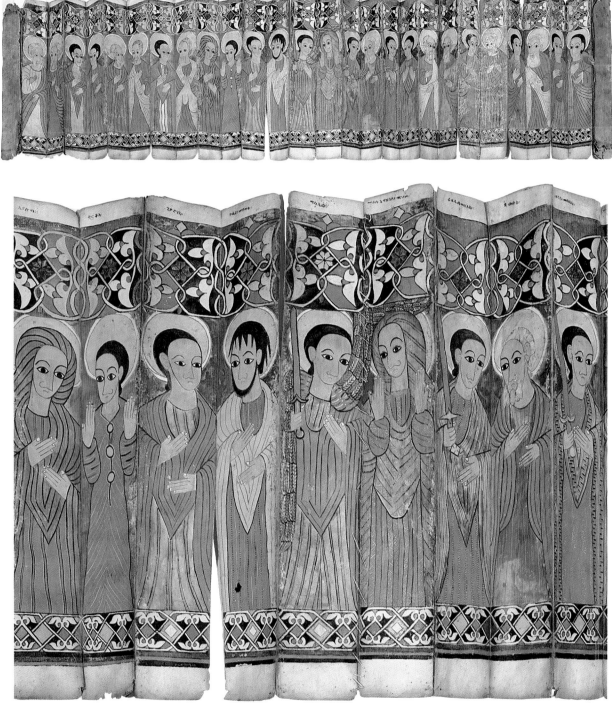

Detail

Cat. 18

Folding Illuminated Book

Ethiopia (Gondar), late 17th century

Tempera and ink on parchment, hide covers

3⅝ x 3⅛ in (9.2 x 9 cm), 10 panels

36.10, museum purchase, the W. Alton Jones Foundation Acquisition Fund, 1996, from the Nancy and Robert Nooter Collection

Painted on a single strip of parchment, this small, folding book, sometimes described as a *sensul*, assumes a form that first appeared in the sixteenth century.[1] These strips, which are typically folded into multiple compartments, feature painted decoration and accompanying inscriptions that identify the picture and include short hymns and prayers.[2] Two hide covers, which might not be original, have been stitched onto either end of the strip to create a protective cover. The small scale of the object, which fits comfortably into a pocket, indicates that it was designed for private devotion. The *Life of Maba Seyon*, a fifteenth-century saint, describes a small painting that could be worn by the owner during the day and suspended over his or her bed at night.[3] Although the object in this story might have been a pendant (see cat. 9), the folding picture-book could be used in the same way.

The book, which unfolds to present a miniature picture cycle, was perfectly suited to its function. The ten panels that make up the object create a pictorial synopsis of the life of Mary, beginning with her birth and ending with her Assumption into Heaven. The fact that each end of the parchment strip incorporates an unpainted margin, which in the first panel features an inscription, indicates that the cycle is complete. In addition to creating a pictorial summary of Mary's life, the strip also incorporates some of the features of a painted icon. The figure of Saint George, who often acted as Mary's messenger, appears next to the Virgin and Child, adopting a format also common among pendant icons (see cat. 27). Their placement within the strip allowed the owner to open the parchment to these two scenes, thereby creating a diptych icon in miniature (detail). The style of the painting, which has connections to both panel painting and manuscript illumination, suggests that the object was produced during the first Gondarine period, perhaps at the end of the seventeenth century.

[1] Heldman in *African Zion* 1993, p. 244.
[2] Appleyard 1993, pp. 111–19; Mercier 2000, p. 138.
[3] Budge 1898, p. 30.

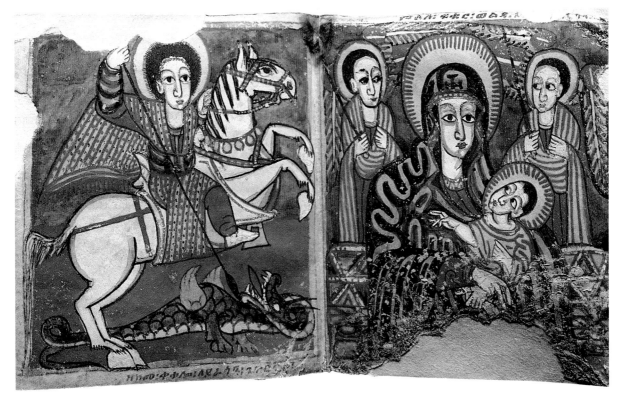

Detail

Cat. 19

Prayer Scroll

Ethiopia, 19th century

Ink on parchment

65⁵⁄₁₆ x 3⁷⁄₁₆ in (166.5 x 8.7cm)

W.788, gift of Mr. James St. Lawrence O'Toole, 1978

Ethiopian prayer scrolls are inscribed with prayers, spells, and charms that were originally designed to offer protection to their owner.[1] Because a prayer scroll's texts were often excerpted from sacred books such as the Gospels, the Ethiopian Church tolerated their production in spite of their connection to magical practices. Clients commissioned scrolls for diverse reasons, using them to undo spells, restore health, combat sterility, and even ward off demons. The *däbtära*, or unordained cleric responsible for producing the object, specifically tailored the size and content of the scroll to the physical and spiritual characteristics of his client, using painted decoration to enhance the scroll's protective properties.

The process began with the selection and sacrifice of a particular animal. The *däbtära* washed the client in the animal's blood as part of the process of purification. Three strips of parchment were then made from the skin of the animal and stitched together to form a single scroll equal in length to the height of the owner. The object, therefore, maintained a direct, physical connection with its owner, enhancing the power of its magic. The parchment was then inscribed in red with the owner's name and with a collection of designs and prayers that together provided its protective magic. Rolled up and stored in a leather container, the scroll was kept with the owner until the desired effect was achieved.

The text immediately below the depiction of the angel on this scroll identifies the original owner as a woman named Martha, who commissioned it because she thought she had been possessed by a devil (detail). After the devil was exorcised, she wore the scroll to ward off any future possession by demons. Written on the scroll are various prayers against malicious demons and evil spirits, including part of a song to the angel Phanuel, the expeller of demons, who may be the angel depicted. The length of scroll, composed of the required three strips of parchment, indicates that Martha was approximately 5'6" tall. As was the case with this object, the majority of people who commissioned such talismans appear to have been women.

[1] Mercier 1979; Mercier 1997.

Detail

The Role of the Painted Icon in Ethiopian Culture

C. GRIFFITH MANN

Zanvyl Kreiger Curatorial Fellow
The Walters Art Museum

During his visit to Ethiopia in the early sixteenth century, the Portuguese chaplain Francesco Alvarez described the ritual veneration of an icon depicting the Virgin Mary. When a priest flanked by two candle-bearers presented the picture to the assembled worshippers, they processed in front of the picture, singing and paying it great reverence.[1] According to her legend, the fifteenth-century Saint Krestos Sämra was praying before an icon when Christ appeared before her and hung a small painting around her neck.[2] Such narratives provide striking reminders of the importance of icons within the devotional life of Ethiopian Christians. Because the painted likeness of a sacred figure was thought to share in the sanctity of the model, icons, whether owned by institutions or individuals, provided a means of communicating with the divine; a way of bridging the gap between the faithful and the sacred figures being venerated.

The development of the painted panel icon in Ethiopia was intimately connected with the rise of the cult of the Virgin Mary in the middle of the fifteenth century. It is therefore extremely rare to find an icon on panel before the reign of Emperor Dawit (reigned 1382–1413), the founder of the Solomonic dynasty. Dawit encouraged devotion to the Virgin, praying daily before a Marian icon.[3] But it was the Emperor Zär'a Ya'eqob (reigned 1434–68), the son of Dawit's third wife, who integrated the veneration of Marian icons into the services of the Ethiopian Church, thereby fueling an unprecedented demand for panel paintings.[4]

Both in his religious tracts and in his poetry, Zär'a Ya'eqob, who was educated in a monastery, demonstrated a particular concern with Marian theology. In 1441, Zär'a Ya'eqob had a Ge'ez version of the *Introductory Rite* added to the *Miracles of Mary*, which he then disseminated. This text established the liturgical function of Marian icons and made their veneration a central part of the ceremonies associated with Sunday services and Marian feasts. In particular, the *Rite* stipulated that priests waft incense around an icon of the Virgin while singing hymns of praise in her honor. Moreover, in his *Book of Light*, Zär'a Ya'eqob specified that during the Sunday Sabbath, churches possessing Marian icons should display them on a throne below a canopy, together with a cross.[5]

As a result of these developments, patrons throughout Ethiopia commissioned pictures of the Virgin on wooden panels, creating a thriving demand for work in this medium that continued into the following centuries. Because the new desire for pictures gave rise to paintings with different functions—devotional, ceremonial, and protective—Ethiopian icons assumed many different forms. Although many were created for use in religious ceremonies, with sizes suited to processions and ritual display, others were small enough to be carried by their owners, providing a constant reminder of their devotion and a guarantee of their security. But perhaps most importantly, the painted icon provided Ethiopian Christians with the likeness of a sacred figure they could venerate and with an object they could cherish. The fifteenth-century Saint Täklä Maryam, as a child, found a painting of the Virgin and Child, pressed the picture to his breast, embraced and kissed it, and refused to give it to his father or anyone else.[6]

Fig. 32

Worshipper with painted icon, detail
from W.835, fol. 115v (cat.15)

[1] Alvarez 1961, vol. 1, pp. 77–79.
[2] Heldman 1994, p. 171.
[3] Haile 1983, p. 31.
[4] Heldman 1994, pp. 163–99; Mercier 2000, pp. 194–95.
[5] Heldman 1994, p. 168.
[6] Budge 1898, p. 11.

Cat. 20

Fre Seyon

Our Lady Mary with Her Beloved Son and Archangels Michael and Gabriel

Ethiopia (Tegray), 1445–80

Tempera on panel

23 x 22¾ in (58.4 x 57.8 cm)

IL 1999.4, on loan from a private American collection

Flanked by an honor-guard of adoring archangels, the Virgin Mary draws the infant Christ into a tender embrace, clasping his left arm in her hand. The interlocking gazes and tilting heads of these two figures provide a sense of intimacy, a feeling that is particularly concentrated where the Virgin's veil brushes against Christ's halo. Although rendered in inverse color schemes, the patterns on their clothing are identical, and thereby strengthen their connection. The three holes in the left edge of the frame indicate that this panel was originally the right half of a diptych, or two-panel icon.

The panel's refined drawing and complex composition suggest that this painting is the work of Fre Seyon (Fruit of Seyon), a court painter to the Emperor Zär'a Ya'eqob (reigned 1434–68). As one scholar has noted, the archangels refer through their weapons to the "sword of the Gospels" and the "axe of the Law"; Zär'a Ya'eqob himself used these metaphors in describing Mary as the figure in whom the Old and New Testaments were united.[1] Fre Seyon graphically expressed the Virgin's importance by filling the painting with her form and cropping her halo to suggest a sense of monumentality.

The disk held by the archangel Michael and identified as the "spiritual mirror" bears the following inscription: "Michael the arch[angel] says, 'Holy is God the only Father, Holy is the Word of God the only Son, Holy is the Paraclete the only Holy Spirit Who sanctified us, blessed us, and gave us eternal life."[2] Containing references to both the Trinity and the Incarnation, or the moment when the Word became Flesh, this prayer was recited over the Eucharistic bread and consequently connects the painting to the celebration of the liturgy. Perhaps more important, this inscription suggests that the icon, which seems to invite meditation on matters of doctrine, was designed for an educated audience.

[1] Heldman 1994, pp. 194–98.
[2] Heldman 1998, p. 50.

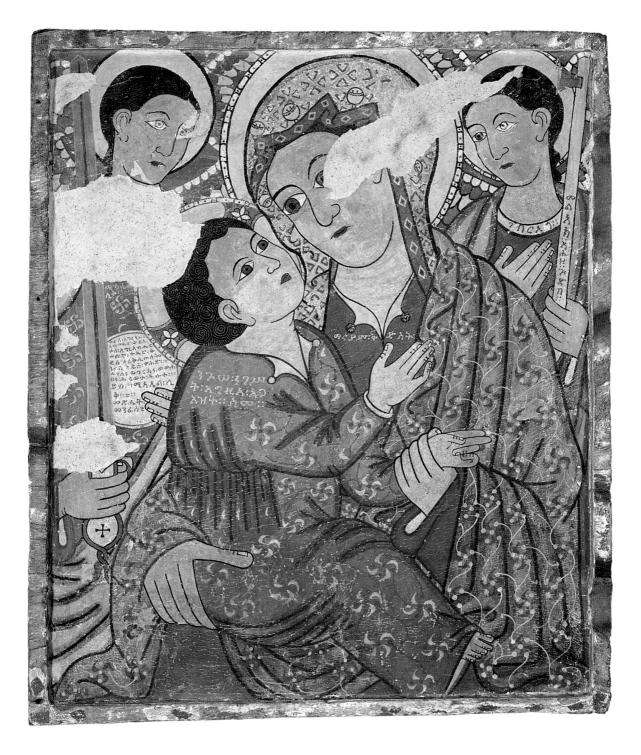

Cat. 21

Follower of Fre Seyon

Diptych with Virgin and Child flanked by archangels, apostles, and Saint George

Ethiopia (Tegray), late 15th century

Tempera on panel

8⅞ x 7 3⁄16 in (22.5 x 19.8 cm) left;
10 1⁄16 x 7¾ in (25.6 x 19.7 cm) right

36.12, museum purchase, the W. Alton Jones Foundation Acquisition Fund, 2001, from the Nancy and Robert Nooter Collection

The two wings of this diptych, still in pristine condition, create a unified composition that is concentrated on Mary and the infant Christ. In the left panel, Christ reaches up to caress his mother's chin as he gazes directly into her face. The figures on the facing panel, who turn towards the seated figures of the Virgin and Child, create a procession of solemn witnesses to the pair's close relationship. The small size of this diptych, which once opened like a small book, further enhances this remarkable sense of intimacy.

The elegant lines of Mary's features epitomize the refined character of the art produced by such painters as Fre Seyon (see cat. 20) for the imperial court in the late fifteenth century. The apostles, led by Peter and Paul in the upper left, each clasp a book but are distinguished by individualized features and garments. Saint George, mounted at the lower right, gathers the reins of his horse in one hand and clutches his spear in the other, his cloak spiraling out behind him.

As is typical in Ethiopian renditions of the Virgin and Child, the two archangels create an honor-guard for the celestial pair, an arrangement that first appeared at the end of the fourteenth century.[1] Later evidence suggests that this iconography emerged within the context of the imperial court. In the early sixteenth century, the Portuguese chaplain Francesco Alvarez described the Ethiopian emperor as similarly flanked by a pair of guards with drawn swords.[2] The umbrella-like arrangement of the archangels' wings also carried imperial associations, as a baldachin, or canopy, placed above the emperor's head was a symbol of his authority.[3] These attributes liken the picture to an imperial reception, with the apostles assuming the role of courtiers. Kneeling before the open diptych, the worshipper would, therefore, have assumed the position of a subject seeking audience before the celestial court.

[1] Heldman 1994, p. 117.
[2] Alvarez 1961, vol. 1, p. 304.
[3] Heldman 1994, p. 77.

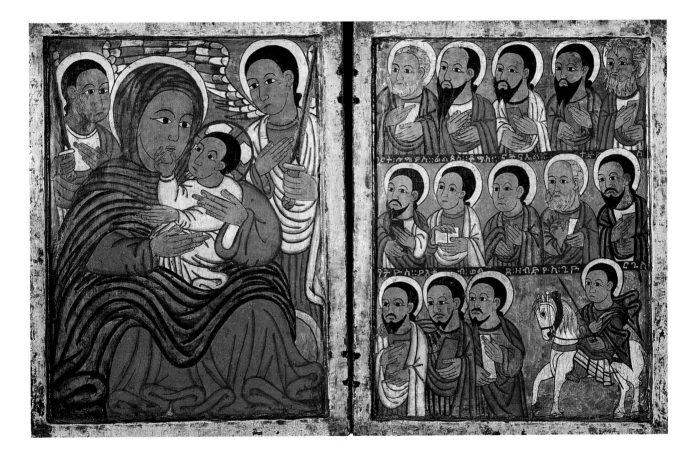

Cat. 22

Anonymous painter

Triptych with the Virgin and Child flanked by archangels, scenes from the life of Christ, and Saint George and Saint Theodore

Ethiopia, early 16th century

Tempera on panel

10⅞ x 3¹⁵⁄₁₆ in (26.5 x 10 cm) left; 10½ x 7¹³⁄₁₆ (26.7 x 19.8 cm) center; 10½ x 3⅞ in (26.7 x 9.8 cm) right

36.6, museum purchase, the W. Alton Jones Foundation Acquisition Fund, 1996

This triptych, or three-panel icon, combines standard devotional scenes with narrative pictures of Christ's life. The central panel, which is divided into two fields, features the Virgin and Child flanked by archangels, with Christ Teaching the Apostles below. In the upper scene, the Christ Child, his head seemingly attached almost arbitrarily to his body, raises his left hand toward his mother's face. Directly below, an adult Christ, with cruciform halo and open book, instructs his apostles, who gesture in response to their master.

The narrative of the life of Christ begins at the top of the left wing with the Nativity and moves down through the Entry into Jerusalem to the Crucifixion. The story resumes in the middle of the right wing with the Entombment and moves upward to conclude with the Anastasis, which in Ethiopian culture symbolizes the Resurrection. The left to right progression of the narrative stands in contrast to tradition, as the Crucifixion typically occupies the right wing and the Anastasis the left. The fact that Saint George, depicted at the bottom of the left wing, battles a wingless serpent suggests an early date for this painting. Winged dragons did not appear in Ethiopian art until Nicolò Brancaleon (ca. 1480–1526), an Italian painter working in Ethiopia, introduced them into the pictorial vocabulary of Ethiopian painting.[1]

Icons executed on white ground are extremely rare. This triptych is, therefore, a unique early example of a technique not commonly employed by Ethiopian artists.[2] The painter here used the white ground to establish a backdrop for his figures. The combination of white and black bands to create contrasting picture fields also has few parallels in Ethiopian painting. The unconventional features of this icon, with its disregard for traditional subject arrangements and playful sense of design, suggest that its painter was working in a period before the typical formats of panel paintings had been firmly established.

[1] Heldman 1994, note 30, p. 57; Mercier 2000, p. 83.
[2] Chojnacki 1974, cat. 117.

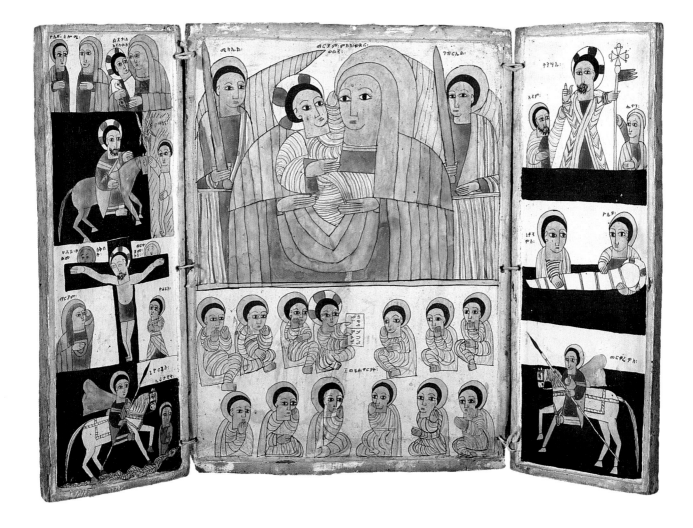

Cat. 23

Anonymous painter

Triptych with the Virgin and Child flanked by archangels, scenes from the life of Christ, Saint George, and Saints Honorius, Täklä Haymanot, and Ewosṭatewos

Ethiopia (Tegray), early 17th century

Tempera on panel

16⅝ x 5⁷⁄₁₆ in (42.2 x 13.8 cm) left;
16¾ x 11¼ in (42.5 x 28.6 cm) center;
16¾ x 5⅝ in (42.5 x 14.3 cm) right

36.4, museum purchase, the W. Alton Jones Foundation Acquisition Fund, 1996

The central panel of this triptych features a version of Mary and the infant Christ based on a famous icon from the Roman basilica of Santa Maria Maggiore that was believed to have been painted by Saint Luke the Evangelist. Prints of this painting entered Ethiopia around the year 1600 with Jesuit missionaries.[1] The widespread circulation of these prints led to the adoption of the Santa Maria Maggiore icon as a prototype for pictures of Mary and Christ and transformed Ethiopia's traditional Marian imagery. In paintings based on this icon, the Christ Child typically sits on the Virgin's left arm while holding a book in his left hand. Mary, crossing her arms in front of Christ, holds a cloth in her left hand and extends the elongated fingers of her right hand toward the ground. As with the original Roman painting, the hood of Mary's cloak often bears a cross.

This triptych, which survives in relatively pristine condition, is a fine example of the work of a group of Ethiopian painters that apparently specialized in producing icons based on the Roman prototype.[2] Yet in their panels, as can be seen here, the western model assumes a new form, with Mary's cloak stretching out in either direction to embrace the scene of Christ Teaching the Apostles below. Umbrella-like, Mary appears as both the protector and personification of the church. The paintings of this school typically combine large figures across the top of all three panels with smaller figures below. These painters also made extensive use of blue grounds, and added fine linear details in black ink.

[1] Pankhurst in *Aspects of Ethiopian Art* 1993, pp. 93–94.
[2] Heldman in *African Zion* 1993, cat. 105; Mercier 2000, p. 144.

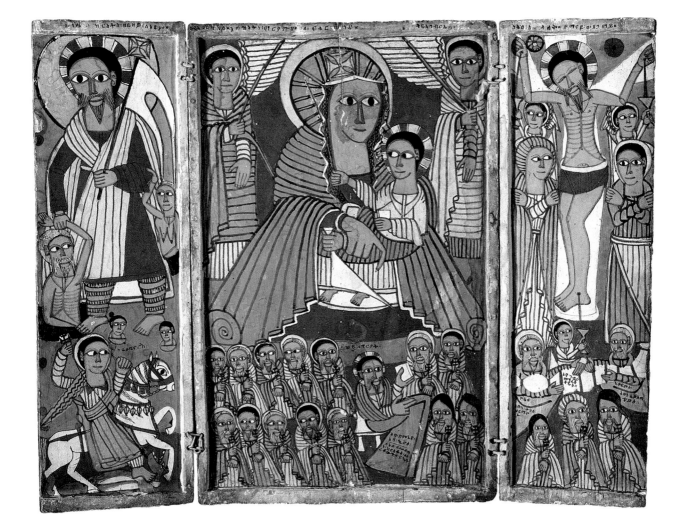

Cat. 24

Anonymous painter

Triptych with Virgin and Child flanked by archangels, scenes from the life of Christ, apostles, and Saint George and Saint Mercurius

Ethiopia (Gojjam?), late 17th century

Tempera on panel

14⅞ x 4⁵⁄₁₆ in (37.8 x 11 cm) left; 15⅛ x 9 in (38.4 x 22.8 cm) center; 15¹⁄₁₆ x 4⁷⁄₁₆ in (38.2 x 11.2 cm) right

36.7, museum purchase, the W. Alton Jones Foundation Acquisition Fund, 1996, from the Nancy and Robert Nooter Collection

The Virgin and Child on the central panel of this triptych are based on the Santa Maria Maggiore icon (see cat. 23) and were, therefore, painted after the turn of the seventeenth century. Although their size ensures their prominence within the painting, it is the eyes of the Virgin and Christ that command attention. Of all the figures depicted in the triptych, only the Virgin in the central panel and Christ in the top of the left wing look directly at the spectator. All of the other figures in the painting gaze to either side, a device used by the painter to show deference to the more important figures of Christ and the Virgin.[1]

The Anastasis featured in this triptych incorporates an important innovation, making this a notable icon in the development of Ethiopian painting. Long a central theme in Ethiopia, the Anastasis typically depicted Christ pulling Adam up from Limbo by his hand. Eventually, however, this image of Christ extracting Adam was joined by another version, in which Christ raises his arms in blessing. The scene depicted here blends these two traditions; although Christ raises both hands in a gesture of benediction, the arms of Adam and Eve have been elongated to reach them. As a result, Christ's right hand holds both a cross (see cat. 7) and Adam's arm.

The Anastasis, which for Ethiopian Christians symbolizes the Resurrection, occupies a central place in the Ethiopian theology of redemption. Adam's connection to this subject is derived from scripture: "For as in Adam all die, so also in Christ shall all be made alive" (I Corinthians 15:22). Through the figures of Adam and Eve, therefore, the Anastasis became an image not just of the Resurrection but also of redemption. The patrons who commissioned painted icons such as this hoped to follow the example of Adam and be redeemed by Christ.

[1] Mercier 2000, p. 138.

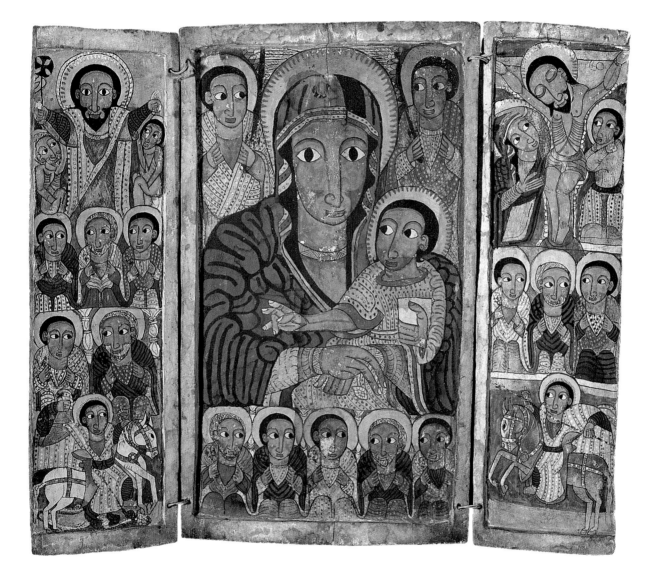

Cat. 25

Anonymous painter

**Diptych with Virgin and Child flanked
by archangels, scenes from the lives of
Christ and the Virgin, and saints**

Ethiopia (Lasta), late 17th–early 18th
century

Tempera on panel

20½ x 10¼ in (52.1 x 26.1 cm) left;
20½ x 10⅜ in (52.1 x 25.9 cm) right

36.3, museum purchase, the W. Alton
Jones Foundation Acquisition Fund, 1996

The paired holes along the outer edge of the right panel indicate that this
painting was originally a triptych, now missing its right panel. What is seen
here as a right wing is, therefore, actually standard iconography for central
panels, combining a Virgin and Child based on the Santa Maria Maggiore icon
(see cat. 23) with Christ Teaching the Apostles.

Although the Anastasis and the Crucifixion typically flank the central panel,
here they appear together on the left wing with other scenes. The Crucifixion,
which in earlier icons includes only the figures of Christ, Mary, and John the
Evangelist, here also depicts the figures of the two thieves. Though this wing
has been damaged, it preserves images of arresting emotional power. Mary,
who gazes upon her son in the Crucifixion, touches her head in a gesture of
grief. In the Entombment, where Joseph and Nicodemus carry the shrouded
body of Christ, Mary covers her face in sorrow. These details stress the Virgin's
participation in Christ's Passion, thereby providing a moving counterpoint to
the central panel, where Mary appears with her infant son.

The density of this icon's pictorial program suggests that the missing panel
also featured an extensive narrative. Because the left wing, which has suffered
significant damage, ends with the Last Judgment, it seems likely that the right
wing opened with early scenes from the life of Christ, such as the Nativity, and
concluded with Passion scenes that preceded the Crucifixion.

The painter's exuberant sense of color is characteristic of early Gondarine
painting, appearing in both icons and works on parchment (see cat. 15). The
alternating horizontal and vertical bands of color connect this painting to works
produced in the region of Lasta.[1]

[1] Mercier 2000, p. 145.

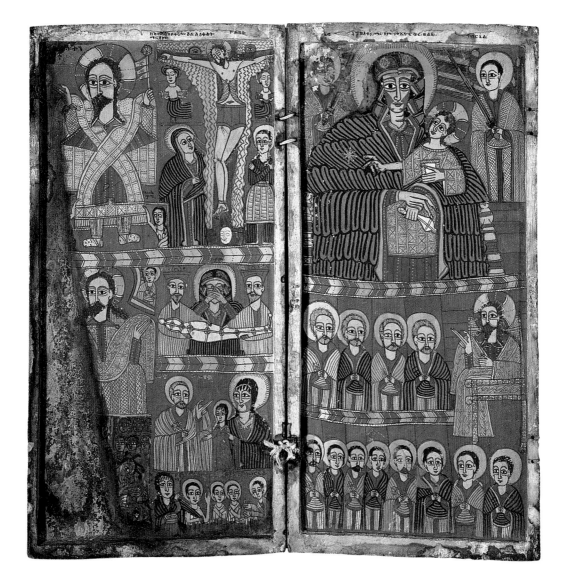

Cat. 26

Anonymous painter

Double-sided pendant with Mary at Däbrä Metmaq, archangels, and saints

Ethiopia (Gondar?), late 17th century

Tempera on panel

4⅜ x 10⅛ in (11.1 x 25.7 cm) open;
4⅜ x 3⅝ in (11.1 x 9.2 cm) closed

36.8, museum purchase, the W. Alton Jones Foundation Acquisition Fund, 1996, from the Nancy and Robert Nooter Collection

The small scale of this painting and its protective covers facilitated its use as a portable icon. The hollow wooden cylinder attached to the body allowed the painting to be suspended from the owner's neck with a string. The practice of wearing icons of the Virgin as pendants is documented in written sources as early as the fifteenth century.

The main scene on this double-sided pendant commemorates the Feast of Däbrä Metmaq (front). According to the *Miracles of Mary*, this feast was instituted to celebrate an event that occurred annually in the church of Dayr al-Magtas, Egypt.[1] For five days each spring, Mary miraculously appeared inside the cupola of the church, and was described as bathed in light and surrounded by angels. Accounts further state that the archangels and saints that accompanied the Virgin bowed before her in veneration. The main panel of this icon captures the visionary character of this event by enclosing the Virgin in a band of yellow light. Seraphim surround the outer border of red. The archangels Michael and Gabriel, depicted on the inside cover, evoke the heavenly hosts that accompanied the Virgin. By representing the major figures, the painter recreated the miraculous apparition in miniature for the pendant's owner.

As the Festival of Däbrä Metmaq was especially important to women, and as the reverse of the pendant also bears the likenesses of two female martyr-saints, the patron of this work might have been female (back). The legend of the fifteenth-century Saint Krestos Sämra describes how Christ bequeathed to her a painting, which he hung pendant-like around her neck.[2] The delicately carved, painted covers transformed the closed pendant into a cherished object of personal devotion.

[1] Heldman in *African Zion* 1993, cat. 14.
[2] Heldman 1994, p. 171.

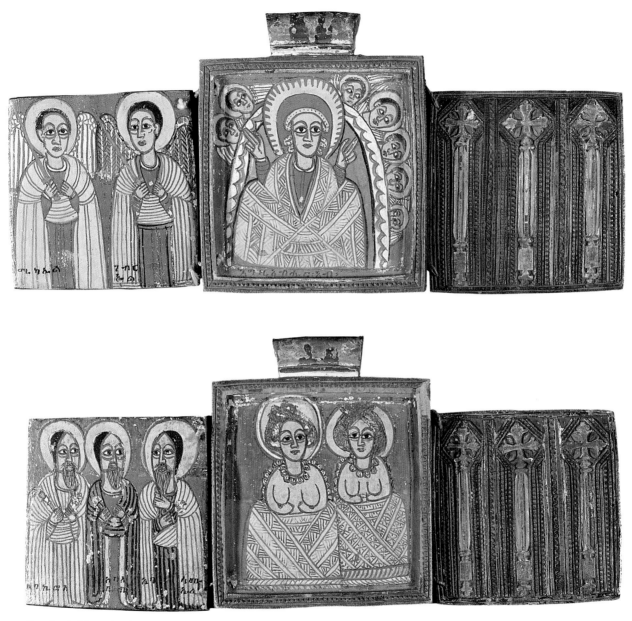

Top: front; *Above:* back

Cat. 27

Anonymous painter

Double-sided pendant with the Virgin and Child with Saint George; Kwer'atä Reesu with Täklä Haymanot and donor

Ethiopia (Gondar?), late 18th century

Tempera on panel

3⁷⁄₁₆ x 5⁹⁄₁₆ in (8.7 x 14.1 cm) open;
3⁷⁄₁₆ x 2⁷⁄₁₆ in (8.7 x 6.2 cm) closed

36.5, museum purchase, the W. Alton Jones Foundation Acquisition Fund, 1996

Although the outer covers of this pendant have been scratched by years of use, the yellow crosses that decorate the exterior remain visible. The hinged covers of the pendant open to reveal images of saints facing famous icons.

The principal painting on the main panel depicts the Virgin and Child in a pose based on the Santa Maria Maggiore icon (see cat. 23). In an unusual detail, Mary and Christ have been depicted on a throne backed with a star-studded cloth (front). The facing painting is of Saint George, the saint about whom Mary is said to have remarked, "George follows me wherever I go. I send him all places for help." The shifting colors of the background behind Saint George connect this pendant with the style of painting that prevailed during the later Gondarine period of the eighteenth century.

On the reverse of the main panel is an image known as the Kwer'atä Reesu, a famous icon depicting Christ wearing the Crown of Thorns (back).[1] Having been mocked and beaten by his captors, Christ holds up his hands before him in a gesture of acceptance. From as early as the seventeenth century, this icon served as the standard of the Ethiopian emperors and hung in the imperial palace at Gondar.

The facing panel depicts the monastic Saint Täklä Haymanot (ca.1214–1313) with a prostrate donor, presumably the pendant's original owner. According to his legend, Täklä Haymanot spent such long hours standing in prayer that his leg broke. He, therefore, typically appears standing on one foot. The donor's identification with Täklä Haymanot is communicated visually not only through his position, but also through his embrace of the saint's good leg.

[1] Chojnacki 1985, pp. 1–64.

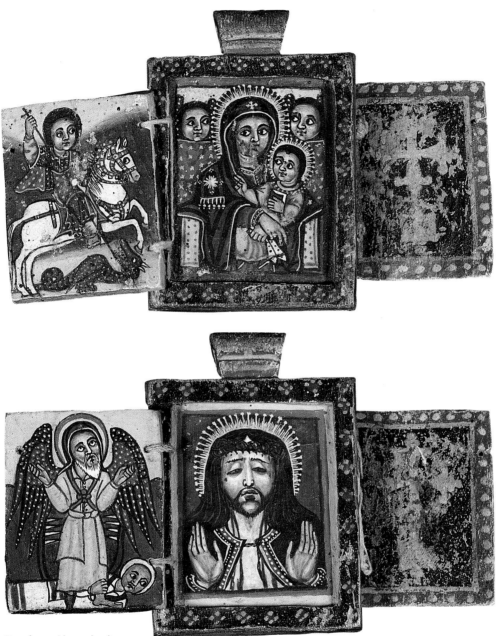

Top: front; *Above:* back

Bibliography

African Zion: The Sacred Art of Ethiopia 1993. Roderick Grierson, ed. New Haven: Yale University Press.

Alvarez, Francesco 1961. *The Prester John of the Indies: A True Relation of the Lands of Prester John, Being the Narrative of the Portuguese Embassy to Ethiopia in 1520*, G. F. Beckingham and G. W. B. Huntingford, eds., 2 vols. Cambridge: Cambridge University Press.

Annequin, Guy 1990. *Aux sources du Nil bleu, enluminures et peintures chrétiennes du XIᵉ au XVIIᵉ siècle.* 2 vols. Geneva: Editions de Crémille.

Appleyard, David 1993. *Ethiopian Manuscripts.* London: Jed Press.

Aspects of Ethiopian Art from Ancient Axum to the Twentieth Century 1993. Paul B. Henze, ed. London: Jed Press.

Balicka-Witakowska, Ewa 1983. "Le Psautier éthiopien illustré de Belén Sägäd." *Ars Suetica* 7: 1–46.

——. 1997. *La Crucifixion sans Crucifié dans l'art éthiopien. Recherches sur la survie de l'iconographie chrétienne de l'Antiquité tardive.* Warszawa-Wiesbaden: Zas Pan.

Basset, René (trans.) 1897. *Histoire de la conquête de l'Abyssinie (XVIe siècle) par Chihab ed-din Ahmed ben 'Abd el-Qâder surnommé Arab-Faqih.* Paris: Ernest Leroux.

Beckingham, C. F. and G. W. B. Huntingford 1954. *Some records of Ethiopia 1593–1646, being extracts from the History of High Ethiopia or Abassia by Manoel d'Almeida, together with Bahrey's History of the Galla.* London: Hakluyt Society.

Bezold, C. (ed. and trans.) 1909. *Kebra Nagast: Die Herlichkeit der Könige.* Munich: Akademie der Wissenschaften.

Bidder, Irmgard 1958. *Lalibela, The Monolithic Churches of Ethiopia.* Cologne: M. DuMont Schauberg.

Budge, E. A. Wallis (ed. and trans.) 1894. *Saint Michael the Archangel: Three Encomiums by Theodosius, Archbishop of Alexandria; Severus, Patriarch of Antioch; and Eustathius, Bishop of Trake.* London: K. Paul, Trench, Trübner & Co.

——. 1898. *The Lives of Maba Seyon and Gabra Krestos.* London: W. Griggs.

—— (trans.) 1922. *The Queen of Sheba and Her Only Son Menyelek.* London: M. Hopkinson.

——. 1928 [reprint 1976]. *The Book of the Saints of the Ethiopian Church.* Reprint, New York: G. Olms.

Chojnacki, Stanislaw 1974. *Éthiopie Millénaire. Prehistoire et art religieux, Petit Palais Novembre 1974–Février 1975.* Paris: Association française d'action artistique.

——. 1983. *Major themes in Ethiopian painting.* Wiesbaden: Franz Steiner Verlag.

——. 1985. "The 'Kwer'ata re'esu': Its Iconography and Significance; An Essay in Cultural History of Ethiopia." Supplement 42 agli *Annali dell'Istituto Universitario Orientale* 45: 1–64.

Cohen, Marcel 1924. *Essai comparatif sur le vocabulaire et la phonétique du Chamito-Sémitique.* Paris: H. Champion.

Conti Rossini, Carlo 1910. "Il convento di Tsana in Abissinia e le sue laudi alla Vergine." *Rendiconti della Reale Accademia dei Lincei, Classe di scienze morali, storiche e filologiche* 19: 581–621.

——. 1922. "À propos des textes éthiopiens concernant Sälama (Frumentius)." *Aethiops* 1, no. 1: 2–4 and 1, no. 2: 17–18.

——. 1928. *Storia d'Etiopia.* Bergamo: Instituto Italiano D'Arti Grafiche.

——. 1941. "Lo 'Awda Nagast: scritto divinitario Etiopico." *Rassegna di Studi Etiopici* 1: 129–45.

—— and L. Ricci (eds. and trans.) 1964. *Il libro della luce del Negus Zär'a Ya'eqob (Mashafa Berhan).* 2 vols. Louvain: Secretariat du Corpus SCO.

Daoud, Marcos and Marsie Hazen (trans.) 1959. *The Liturgy of the Ethiopian Church.* Cairo: Egyptian Book Press.

Dillmann, August 1865 [reprint 1970]. *Lexicon linguae Aethiopicae.* Reprint, Osnabrück: Biblio.

——. 1879. "Über die Anfänge des Axumitischen Reiches." *Abhandlungen der Königlichen Akademie der Wissenschaften zu Berlin, Philos.-histor. Kl.* Berlin.

Di Salvo, Mario 1999. *Churches of Ethiopia. The Monastery of Nãrgã Śellãśē.* Milan: Skira.

Gerster, Georg 1970. *Churches in Rock. Early Christian Art in Ethiopia,* Richard Hosking, trans. New York: Phaidon.

Getachew Haile 1979. A Catalogue of Ethiopian Manuscripts Microfilmed for the Ethiopian Manuscript Microfilm Library, Addis Ababa, and for the Hill Monastic Manuscript Library, Collegeville, vol. 4. Collegeville, Minnesota.

——. 1982. "A New Look at Some Dates of Early Ethiopian History." *Le Muséon* 95, no. 3–4: 311–22.

——. 1983A. "The case of the Estifanosites: a Fundamentalist sect in the Church of Ethiopia." *Paideuma* 29: 93–119.

——. 1983B. "Documents on the History of Ase Dawit (1382–1413)." *Journal of Ethiopian Studies* 16: 25–35.

—— (ed. and trans.). 1979. "The Homily in Honour of St. Frumentius Bishop of Axum (EMML 1763, ff. 84V–86r)." *Analecta Bollandiana.*

——. 1991. *The Epistle of Humanity of Emperor Zär'a Ya'eqob (Tomara Tesbet).* Louvain: E. Peeters.

——. 1992. *The Mariology of Emperor Zär'a Ya'eqob.* Rome: Pontificium Institutum Studiorum Orientalium.

Greenberg, Joseph Harold 1966. *Languages of Africa.* Bloomington, IN: Indiana University Press.

Haberland, Eike 1964. "The Influence of the Christian Ethiopian Empire on Southern Ethiopia." *Journal of Semitic Studies* 9, no. 1: 235–38.

——. 1965. *Untersuchungen zum äthiopischen Königtum.* Wiesbaden: Franz Steiner Verlag.

Heldman, Marilyn 1972. "Miniatures of the Gospels of Princess Zir Ganala: An Ethiopic Manuscript Dated A.D. 1400/1401." Ph.D. diss. Washington University, Saint-Louis.

——. 1984. "The Role of the Devotional Image in Emperor Zär'a Ya'eqob's Cult of Mary." In *Proceedings of the Seventh International Conference of Ethiopian Studies, University of Lund, 26–29 April 1982,* 131–42. East Lansing: African Studies Center, Michigan State University.

——. 1994. *The Marian Icons of the Painter Fre Seyon. A Study in Fifteenth-Century Ethiopian Art, Patronage and Spirituality.* Wiesbaden: Harrassowitz Verlag.

——. 1998. "Fre Seyon. A Fifteenth-Century Ethiopian Painter." *African Arts* 31, 48–55.

Hussey, R. (ed.) 1853. *Historia Ecclesiastica.* Oxford: Academic Press.

Jäger, Otto 1957. *Äthiopische Miniaturen.* Berlin: Mann.

Jones, A. and E. Monroe 1955. *A History of Ethiopia.* Oxford: Clarendon Press.

Kaplan, Steven 1984. *The Monastic Holy Man and the Christianization of early Solomonic Ethiopia.* Wiesbaden: Franz Steiner Verlag.

Korabiewicz, Waclaw 1971. *The Ethiopian Cross.* Addis Ababa: Holy Trinity Cathedral.

Langmuir, Elizabeth Cross, Stanislaw Chojnacki, and Peter Fetchko (eds.) 1978. *Ethiopia. The Christian Art of an African Nation.* Salem, MA: Peabody Museum of Salem.

Lepage, Claude 1973. "L'église de Zaréma (Ethiopie) découverte en mai 1973 et son apport à l'histoire de l'architecture éthiopienne." In *Comptes-rendus des séances de l'Académie des Inscriptions et Belles-Lettres,* 416–54. Paris.

——. 1974. "Révélation d'un manuscrit particularièrement fascinant de l'Ethiopie au 15e siècle." *Connaissance des arts* 274: 93–99.

——. 1976. "Dieu et les quatre animaux célestes dans l'ancienne peinture éthiopienne." *Documents pour servir à l'histoire de la civilisation éthiopienne* VII: 70–112.

——. 1987. "Reconstitution d'un cycle protobyzantin à partir des miniatures de deux manuscrits éthiopiens du XIVe siècle." *Cahiers archéologiques* 35: 159–95.

——. 1997A. "Une origine possible des églises monolithiques de l'Ethiopie ancienne." In *Comptes-rendus des séances de l'Académie des Inscriptions et Belles Lettres,* 199–212. Paris.

——. 1997B. "Première iconographie chrétienne de Palestine: Controverses anciennes et perspectives à la lumière des liturgies et monuments éthiopiens." In *Comptes-rendus des séances de l'Académie des Inscriptions et Belles-Lettres,* 739–42. Paris.

Leroy, Jules 1961. "L'évangéliaire éthiopien illustré du British Museum (Or. 510) et ses sources iconographiques." *Annales d'Ethiopie* IV: 155–81.

——. 1962. "Recherches sur la Tradition Iconographique des Canons d'Eusèbe en Éthiopie." *Cahiers Archéologique* 12: 173–204.

——. 1967. *Ethiopian Painting in the Late Middle Ages and During the Gondar Dynasty.* New York: F. A. Praeger.

Leslau, W. 1983. "Popular Interpretation of Dreams in Ethiopia." In *Guirlande pour Abba Jerome,* ed. J. Tubiana, 61–82. Paris: Le Mois en Afrique.

Lings, Martin 1983. *Muhammad: His Life Based on the Earliest Sources.* New York: Inner Traditions International.

Matthews, Derek and Antonio Mordini 1959. "The Monastery of Debra Damo, Ethiopia." *Archaeologia* XCVII: 1–58.

Mercier, Jacques 1979. *Ethiopian Magic Scrolls.* New York: G. Braziller.

——. 1999. "Les sources iconographiques occidentales du cycle de la vie du Christ dans la peinture éthiopienne du dix-huitième siècle." *Journal Asiatique* 287/2: 375–94.

——. (ed.) 1992. *Le roi Salomon et les maîtres du regard. Art et médecine en Ethiopie.* Paris: Réunion des Musées Nationaux.

——. 1997. *Art that Heals. The Image as Medicine in Ethiopia.* New York: Museum for African Art.

——. 2000. *L'Arche éthiopienne, art chrétien d'Éthiopie 27 septembre 2000–7 janvier 2001.* Paris: Paris Musées.

Migne, J.-P. (ed.) 1849. *Rufini Aquileiensis Presbyteri, Historia Ecclesiastica. Patrologia Latina, vol.* 21. Paris.

Moore, Eine 1971. *Ethiopian Processional Crosses.* Addis Ababa: Institute of Ethiopian Studies, Haile Selassie I University.

Munro-Hay, Stuart and Bent Juel-Jensen 1995. *Aksumite Coinage.* London: Spink.

Plant, Ruth 1985. *Architecture of the Tigre, Ethiopia.* Worchester: Ravens Educational and Development Services.

Playne, Beatrice 1954. *St. George for Ethiopia.* London: Constable.

Polotsky, H. J. 1964/69. "Aramaic, Syriac, and Ge'ez." *Journal of Semitic Studies* 9: 114–21.

Proceedings of the First International Conference on the History of Ethiopian Art, London, 1986 1989. London: Pindar Press.

Religiöse Kunst Äthiopiens/Religious Art of Ethiopia 1973. Stuttgart: Institut für Auslandsbeziehungen.

Rodinson, Maxime 1964/69. "Sur la question des 'influences juives' en Éthiopie." *Journal of Semitic Studies* 9: 11–19.

Skehan, Patrick W. 1954. "An Illuminated Gospel Book in Ethiopic." In *Studies in Art and Literature for Belle da Costa Greene*, ed. Dorothy Miner, 350–57. Princeton: Princeton University Press.

Skrobucha, Heinz 1983. *Äthiopische Kreuze: Funktionen, Brauchtum, Formen*. Greven: Eggenkamp.

Spencer, Diana 1972. "In search of St. Luke Ikons in Ethiopia." *Journal of Ethiopian Studies* X/2: 67–95.

Staude, W. 1959. "Etude sur la décoration picturale des églises Abbâ Antonios de Gondar et Dabra Sinâ de Gorgora." *Annales d'Ethiopie* 3: 185–250.

Szymusiak, J. M. (ed.) 1958. *Athanase d'Alexandrie, Apologie à l'Empereur Constance. Apologie pour sa fuite* Paris: Du Cerf.

Trimingham, J. Spencer 1952. *Islam in Ethiopia*. New York: Barnes and Noble.

Tzadua, Paulos and P. L. Straus (eds. and trans.) 1968. *The Fetha Nagast: the Law of the Kings*. Addis Ababa: Haile Selassie I University.

Ullendorff, Edward 1956. "Hebraic-Jewish Elements in Abyssinian (Monophysite) Christianity." *Journal of Semitic Studies* 1/3: 216–56.

——. 1968. *Ethiopia and the Bible*. London: Oxford University Press.

UNESCO 1961. *Ethiopia. Illuminated Manuscripts*. New York: New York Graphic Society.

Wendt, K. 1964/69. "Der Kampf um den Kanon Heiliger Schriften in der äthiopischen Kirche der Reformen des XV. Jahrhunderts." *Journal of Semitic Studies* 9: 107–13.

Whiteway, Richard S. (ed. and trans.) 1902. *The Portuguese Expedition to Abyssinia in 1541–1543 as Narrated by Castanhoso*. London: Hakluyt Society.

Wright, Steven 1961. *Ethiopia. Illuminated Manuscripts*. Greenwich, CT: New York Graphic Society.

Index

DATE DUE

JUL 0 1 2003	
JAN 0 2 2008	
JAN 0 4 2010	
OCT 2 9 2009	

GAYLORD PRINTED IN U.S.A.

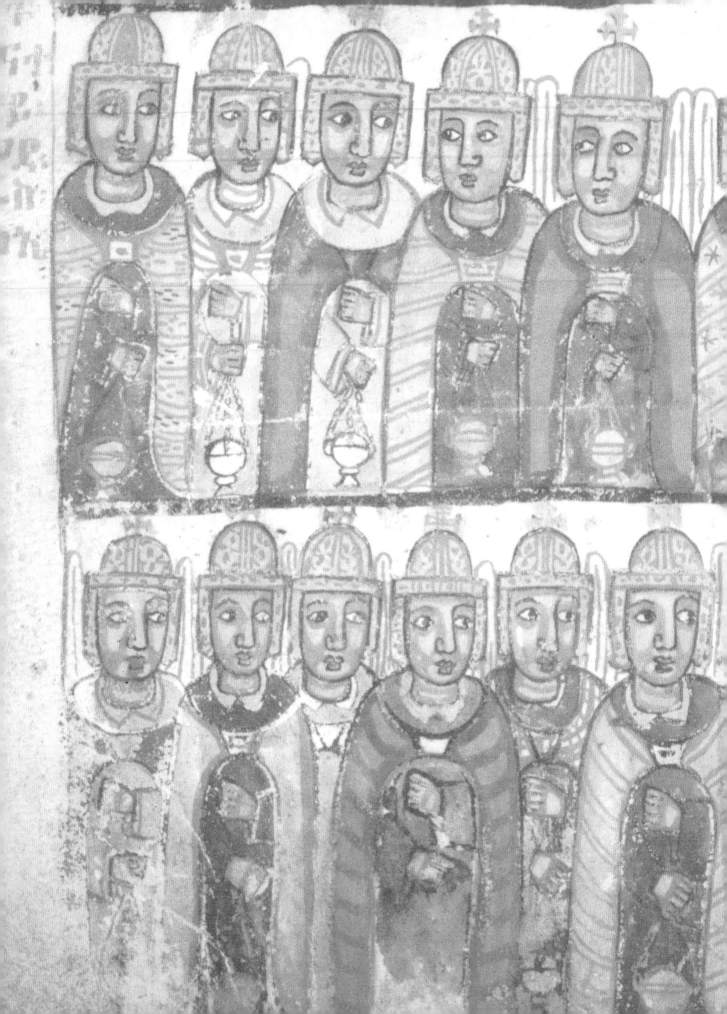